Outstanding illustration artists in Asia

亞 洲 傑 出 插 畫 創 作 精 選

書籍介紹 Introduction

AAD亞洲傑出插畫創作精選，是一本收錄亞洲各國在插畫創作領域中，不論是在內容敘事手法、風格獨特性、視覺表達技巧等面向上表現傑出的優秀創作者。我們藉由這樣的出版計劃，推廣優秀的插畫家與精彩的創作作品，預計也將在2016／2017年籌劃舉辦主題性的展覽和交流講座等活動。並發送本出版品到亞洲地區許多知名的設計機構和畫廊。

"AAD outstanding illustration artists in Asia" will record the artist not only focus on describing techniques, style but also visual expression. Throughout this plan, we want to promote those outstanding illustrators and their remarkable works through this meaningful project. In the future, there would be a thematic exhibition and exchange seminar in 2016/2017. Meanwhile, ADD will deliver this publication to those famous design institutes and galleries.

編者序　Prologue

《AAD 亞洲傑出插畫創作精選》是 AAD 亞洲視覺藝術交流平台，針對亞洲插畫發展現況感興趣的讀者所量身訂做的專業書籍。收錄許多具備未來發展潛力的新一代插畫家，讀者透過每一件作品感受到未來十年亞洲插畫創作的嶄新方向，同時也鼓勵想投入插畫創作的讀者，抱持著積極勇敢的態度去表達自我的信念與價值觀。試圖透過這樣的平台，希望讓更多歐美國家的讀者認識傑出的亞洲插畫創意人，進而在歐美市場上找到更多揮灑才華的空間。也期待更多創作人能透過這本書重拾對於創作的熱情，祝福大家。

"AAD outstanding illustration artists in Asia" is a tailored professional book, which focus on the development of Asian illustration. It includes many potential illustrators in new generation. Readers may find new direction for Asian illustration in the coming decade with the works. Meanwhile, it also encourages readers who want to join illustration field with brave and positive attitude to express their idea and value. With the platform, we hope that readers from Europe and America will know more about Asian illustrators. At the same time, the illustrators can find more space to show their talent. We hope that the book can help the artist to regain the passion of creation. All the best.

AAD 亞洲傑出插畫創作精選
總編輯 陳育民

AAD outstanding illustration artists in Asia
Chief Editor CHEN YU-MING

目錄 Contents

Monica Sutrisna
www.monicasutrisna.com

相較於強烈色彩和顯眼圖案，Monica Sutrisna 的藝術風格為半抽象、寫實的當代單色繪畫。Monica Sutrisna 使用的媒材只有石墨、水彩、色鉛筆、麥克筆和鋼筆。

My artistic style is fixed on semi-abstract, realistic and comtemporary monochromatic portraits contrasted by an intense color palette and aggressive patterns. I use graphites, watercolors, colored pencils, markers and pens as my only mediums.

⌂ Melbourne, Australia
✉ contact@monicasutrisna.com

《My Own Reflection III》 這幅作品反映了我身為設計師以及藝術家的自我，並強調我的藝術與創意的付出。藉由混合媒材，包含鉛筆、麥克筆、原子筆與水彩，突顯我身為許多領域之間溝通的設計師角色，而不是過去單純的純視覺角色。

《My Own Reflection III》 It places heavy emphasis on my artistic and creative attributes and is a reflection of who I am as a designer and artist. Using mixed media including pencils, markers, pens and paints as my only mediums, it highlights the fact that my role as a communication designer practices many areas than what is traditionally defined as graphic and visual.

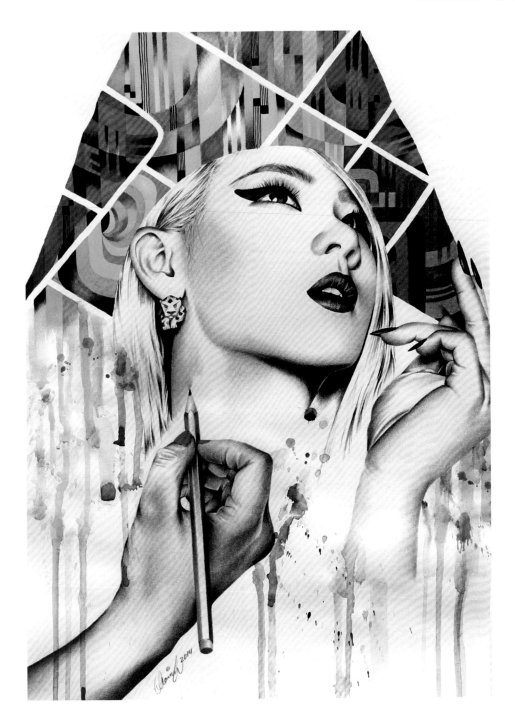

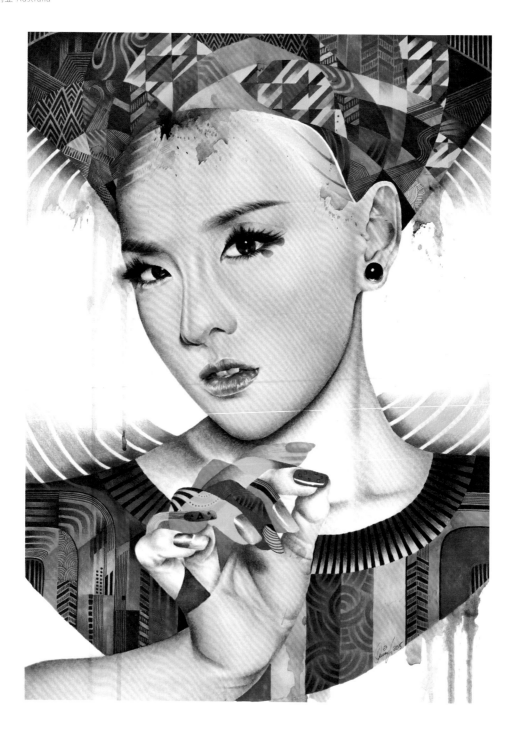

1.《Sunbeams》 Sunbeam（澳洲品牌）藉由探究外型與形式的微妙平衡，創造均勻且和諧的組合。其顏色受到女性的妝容所影響，當你一覽作品時，將可看到戲劇性的對比。 2.《Solar》 抽象與寫實巧妙融合的描繪，創作出獨特光影的灰階影像。

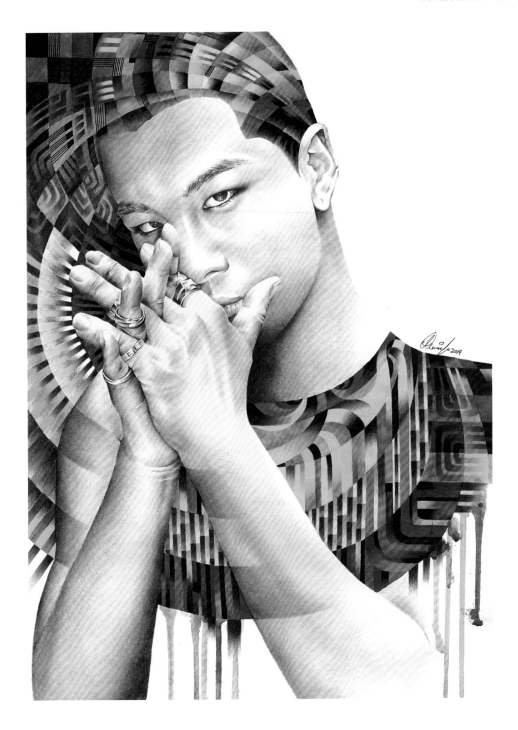

1. 《Sunbeams》 Sunbeams explores the subtlety of movement through the balance of shape and patterns working together to create an almost symmetrical and harmonious composition. The colors are influenced by the make-up on the woman's face, creating dramatic contrasts of elements as you scan through the artwork. 2. 《Solar》 An expressive portrait that balances skillfully between abstract and realistic and creates a unique combination of vibrant colors and thoughtful shaded grayscale.

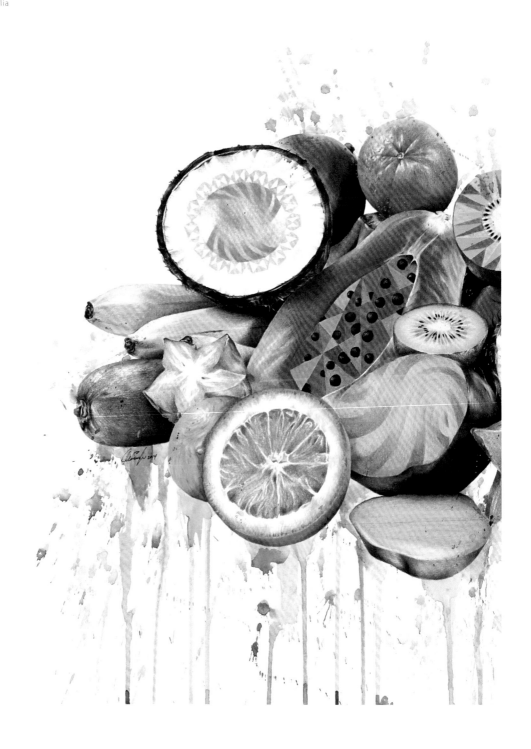

1.《Fruit Salad – Tropics》 該作品可以單獨欣賞或是與另一個名為「Berries」的作品一起觀看。我想賦予被認為無聊的物品生命力。我結合不同形式與大膽的水彩潑墨形式，讓水果擁有更豐富的色彩與生命力。這是水果盛宴！ 2.《Fruit

Salad – Berries》 該作品可以單獨欣賞或是與另一個名為「Tropics」的作品一起觀看。我想賦予被認為無聊的物品生命力。我結合不同形式與大膽的水彩潑墨形式，讓水果擁有更豐富的色彩與生命力。這是水果盛宴！

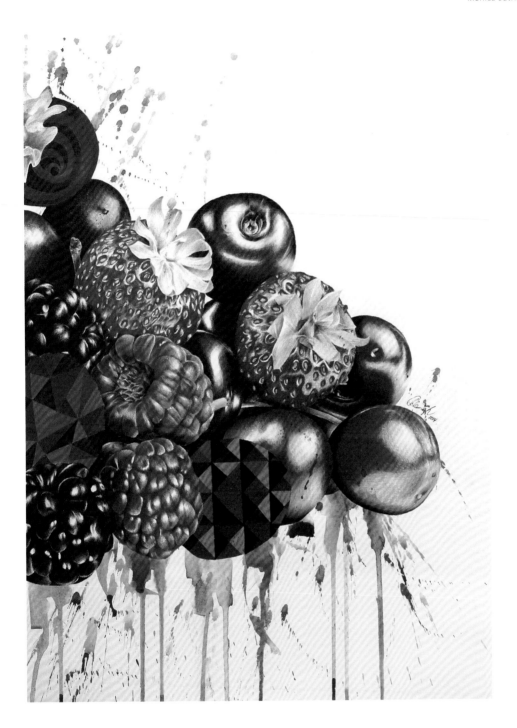

1.《Fruit Salad – Tropics》 The piece can be viewed separately or together with the other artwork called "Berries". I wanted to bring life to a subject matter that is usually considered as "boring" to draw. I've incorporated some interest through unusual patterns and aggressive splashes of watercolors that make the fruits look like they are bleeding with color and excitement. It's a party of fruit!

2.《Fruit Salad – Berries》 The piece can be viewed separately or together with the other artwork called "Tropics". I wanted to bring life to a subject matter that is usually considered as "boring" to draw. I've incorporated some interest through unusual patterns and aggressive splashes of watercolors that make the fruits look like they are bleeding with color and excitement. It's a party of fruit!

1｜2

3.《Lines》 知名女子團體2NE1中的CL，反映了韓國流行樂的重要性，以及這類音樂風格在近幾年大放異彩。然而在同時，媒體太關注於韓國流行樂歌手的外表，只給他們唯有擁有「好看外表」才能在藝壇成功的意象。我們傾向欣賞他們的外表而不是音樂的才華，然而這也是我們該關注的。 3.《CMYK》 做為一位設計師，我有數不盡的作品是CMYK模式。每一個作品我都會去改變它的配色並尋求可其他組合方式。我受到CMYK模式的啟發做了新的配色。以幾何形狀、組成的密鋪圖形，名為Dara的女人，以鮮明的特質與前衛的時尚品味散發其美麗之姿。

3. 《Lines》 Featuring CL from the famous girl group 2NE1, she reflects the vitality of kpop music and how the genre has "blossomed" over the years. However at the same time, the media focuses too much on the physical appearance of kpop artists, giving the impression that only "good-looking" people can succeed in the entertainment industry. We tend to appreciate their image more than their musical talent when really it should be the other way around. 3. 《CMYK》 As a designer I've lost count of the amount of times I've created designs in CMYK format. With every artwork I do I tend to change the color scheme and for this new piece I was searching for another combination. I was clearly inspired by the CMYK color model as my new palette. Made up of tessellating shapes with a cubist style, the woman, Dara, is a person that exudes beauty with sharp traits and embodies edgy taste in fashion.

何钒 Jan

jan.artp.cc

何釩是來自中國的影視、遊戲、動畫概念設計師。同時也是個文學愛好者，對好的故事很敏感，很容易被生活中美好的事物感動。

Jan ,Chinese.He is an independent concept artist who work for animation,film and game.Meanwhile, he was also a literature enthusiasts, very sensitive to good stories,easily moved by finer things in life.

⌂ 中國北京市通州區通惠南路4號院怡佳家園2號樓2902
Rm.2902,Building #2,Yijiajiayuan,No.8 Tonghuinan RD.,Tongzhou Dist.,Beijing,China,101199
✉ *cg.jan.studio@gmail.com*

《普羅米斯森林》有關森林的題材一直都是我喜歡的主題。所以有幾張這樣的小故事，總覺得森林是一種很有靈氣，很神秘的地方，裡面有很活躍的生物，也有很靜穆的植物。可以有很多不同節奏的故事發生。

《Promise Forest》 Forest-related theme has always been my favorite theme. So there were a couple of small stories,the forest is a very smart, very mysterious place, which has very active creatures, also has solemn plants. There can be many dierent rhythms of the story.

1.《臥佛山》臥佛山是一片邪惡的森林，這片土地現在被 " 黑暗力量 " 佔據。但這片土地上一任的主人是東方的神秘僧人，山前的森林是僧人們修行的聖地，任何殺戮禁止在這片森林進行，人稱——戒林。被 " 黑暗力量 " 佔據後，這個規矩一直延續到現在，因為慢慢的所有人都知道，這個規矩不是人們定下來的，是森林定的……

2.《樹城淪陷之序——發現》樹城原本不叫「樹城」，而是以前坐落在鐵匠山中，被素河環繞的一個王國。因鐵匠山盛產金礦，素河河床有大量的銀礦，所以王國被外族稱為「金國」。但金國人因某種原因漸漸喪失繁育能力，金國秉著自己的財富購買了大量的外族人，故沒有統一的名族，就連國王的貼身侍衛也不是本國人。金國703年，國王中毒身亡，王后怕王子尚幼，外族會藉此機會入侵，不分晝夜舉國搬遷到了深谷之中，改名「樹城」，把整個王國隱藏起來。但王子自幼在與世無爭的深谷之中長大，胸無大志，慢慢地金國變成一個脫離外界卻隱藏著巨大財富的世外桃源。另一邊外族因覬覦金國的財富一直在尋找當年富裕強盛卻突然消失的金國。直至金國1314年，因「樹城」中大量的金屬物質漸漸改變了深谷的磁場，被外族的獵人發現，「樹城」開始淪陷了……

1.《Wofu Hill》 The Wo Fo Hill is a evil forest,now this land is occupied by "the black forces".But the former owner of this land was a mysterious oriental monk. Forest of mountainside is a sanctuary where monks can took practice.Prohibit any killings carrie out in this forest,people call it"Ahimsa Forest".After it was occupied by "the black forces",This tule has been extended to the present,because everyone knows that gradually,this rule was not set by people,but by the forest...... 2.《Preface of Tree City's Falling—Discover》 The Tree City had not called "Tree City" originally, but a kingdom that located in the Blacksmith Hill previously, also surrounded by Su River. Because Blacksmith Hill was rich in gold mine, there are plenty of silvers in riverbed of Su River, so the kingdom was called "Kin Empire" by foreign. However, for some reasons, people of Kin Empire gradually lost the ability of breeding, they bought a lot of aliens with its own wealth. Therefore, there is no uniform national, neither the king's personal bodyguard. In Kin Empire 703, the king died of poisoning, and the queen feared that the prince was too young to oer the opportunity for alien invading their empire, so the whole country moved to the deep valley both day and night. After that "Kin Empire" renamed the "Tree City", and hide the whole kingdom. But the prince grown up in the valley among his childhood and with no ambition in such undisturbed environment, gradually Kin Empire changed into arcadia that from the outside world but had great wealth. On the other side, the alien was nding the Kin Empire where was rich and powerful but then suddenly disappeared. Until Kin Empire 1314, it was found by foreign hunter because of a large number of metal materials of the "tree city" gradually changed magnetic eld of the valley, so "Tree City" began fallen

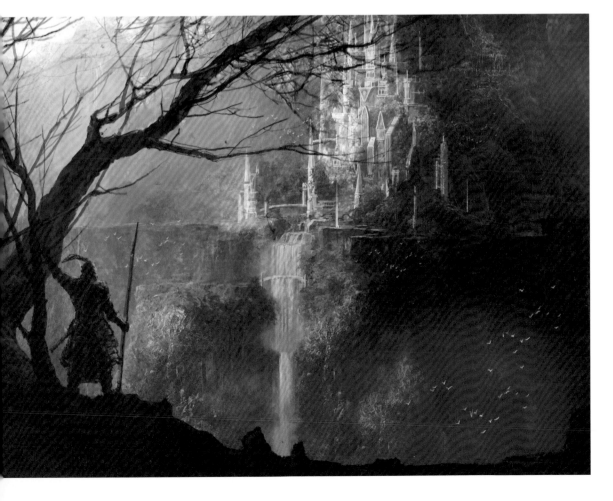

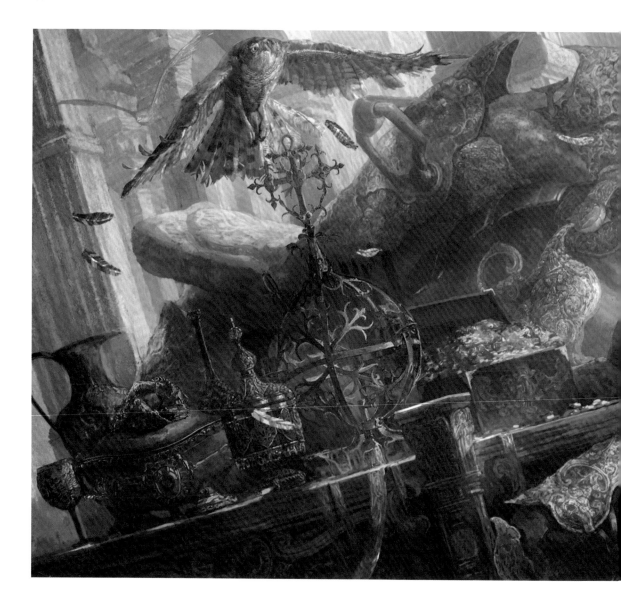

《樹城淪陷之金國大將——龍》金國人，無名無號，無親無故。身材魁梧，體力過人，傳說「素心石」（金國王座所用石材，日光下無異於其實石頭，月光下可使王殿光若白晝）便是他一人從「霧羲坑」（金國最深的礦坑）背上來的。平時沉默寡言，雖面容和善，生性卻極其殘暴，年輕時因血洗鹿耳莊被流放到霧羲坑，終生不得回到地面。因「素心石」一績，金國國王將他從礦井中赦免，並封為金國第一力士。隨後成為金國的"王牌清道夫"，並且不隸屬於任何軍隊或其他武裝力量，只對國王一人負責（國王對他下達命令時從沒第三人在場）。因年輕採礦時拾得幼龍並將其養大，能通獸語，後來更自創刑罰——龍刑（將活人餵食龍），人稱「龍煞」。龍煞離群索居，住在金國廢棄的王殿——鷹巢宮，傳聞鷹巢有一種翠鷹，羽毛為黯啞的熒光藍，金國上下無一畫師能調出此顏色，從前王室每年會遣人生拔翠鷹的羽毛作為裝飾材料（翠鷹死時羽毛顏色驟失光澤）。自從龍煞入住鷹巢宮，無人敢再靠近此宮。金國703年，國王中毒身亡，龍煞失蹤。所有人都認為是龍煞弒君潛逃，但是一直到金國變成樹城時，人們都偶爾能在王國周圍聽到龍嘯……

《Tree City's Falling － Nons》 The man who was from Kin Empire had no name, no family and no friends. He was so burly and powerful. It is said that he carried the "Susan Stone" (the stone was used to made the throne of the king, this stone is ordinary as any others in the sunlight, but when it placed in the moonlight, it lighten the whole palace as well as in daytime) from the "Wolf girl Pit" (the deepest pit in Kin Empire) himself. This man is so taciturn. He has a brutal heart although he looks kindly. When he was young, he was exiled to the " Wolf girl Pit" and couldn't back to the ground until he die because of all the lives in" Towler Village"were ended by him. But because of the "Susan Stone" , he was amnestied and named "The No.1 Protectorate" by the king, and then "The No.1 Killer", which out of any armed forces and responsible only to the king (there has no any other people presence when the king gave him orders). In addition, he feed a dragon that adopted as a baby dragon when he worked in the pit. Naturally,

he could understand animal language, gradually, this man invented a new punishment Dragon punishment (use prisoner to feed the dragon), people were so afraid of him that call him"Nons", which means a delirious man. Mr. Nons lived in a deserted palace Aerie Palace, it is said that there has a kind of eagle the King Eagle , this eagle's feather was dim dumb uorescence blue , this color was so special that couldn't compounded by all the painters from Kin Empire. So that, for the desires, the Royal family sent people to pull the feathers from the eagle when the eagle was lived (the King Eagle's feather will lost luster when it died). Since Mr. Nons moved into the Aerie Palace, nobody dare to close to this palace. In Kin Empire703, the king died of poisoning, and Mr. Nons disappeared after that. Everyone thought he was a absconding Kingslayer. But until the Kin Empire turn into the Tree City, people could heard the roar of dragon around the king...

《重返地球》 3182年1月23日／一年的申請流程，今天終於把我的研究項目批
下來了一《碳基生命中鹼性碎片的記憶結構》。其實這個題目我也是很謹慎地編
造出來的，因為如果沒有很有價值的科研目的的話，政府是絕不會給我一絲絲
回去的可能的。今天的「蟲洞」實驗也是驚心動魄，不過幸運的是我總算來到這
個「前人類」居住的星球—2198的地球。但是我氣瘋了！「蟲洞」實驗小組肯定
弄錯了是時間，我要去的是地球生命完全滅亡後的地球，他們卻把我弄到了侏
羅紀時代！！！直到我看到了「教堂」時，我覺得是我錯了……

《Return to the Earth》 23 January 3182 Sunny / A year for the process of application, and nally I get my research project today-- 《Memory structure of alkaline fragmentation with Carbon-based life》. In fact, I worked out this topic very carefully. Because the government will never give me chance to return to the Earth if this research has no valuable with scientic purposes.

Today's "wormhole" experiments are thrilling. Fortunately I nally came to this Planet of "pre-human" —the Earth of 2198. But I really angry that "Wormhole" experimental group is denitely make wrong time, they send me to the Jurassic era but actually I want to go to the Earth that all life had totally die out. But I think I was wrong until I saw the "church" ······

1 | 2

1.《黑瓜子行動》 公元1328年，赫爾爾文明發展到鼎盛時期時，破壞了「黑森林」規則，暴露了自己的坐標，代號N28星球上的巴艾克文明悄然而至，在宇宙中抹滅了赫爾爾文明，此次突襲行動以「黑瓜子」戰機為先遣部隊，故此次戰役被宇宙先民稱為「黑瓜子」行動。 2.《白雪》 獻給敬愛的埃舍爾／每個世界都有／一個皇后／一個城堡／一個蘋果／一個深影／有時／那還會有一根箭

1.《Black Seeds Action》 AD1328，when Heerer civilization developed to the heyday,had destroyed the rules of "Black Forest" and exposed its coordinates.The Ballgo civilization of planet which named N28 quietly emerged.It estroyed the Heerer civilization in the universe.Vanguard of this raid was "Black Seeds"ghters,so the battle is known as the "Black Seeds"Action. 2.《The White》 To dear M.C.ESCHERAll / stories have / a queen / a castle / an apple / and / a shadow / occasionally, / there will be / a root of / rrows.

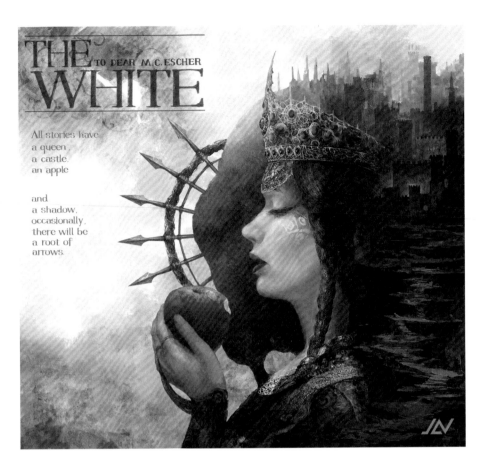

THE
TO DEAR M.C.ESCHER
WHITE

All stories have
a queen,
a castle,
an apple

and
a shadow,
occasionally,
there will be
a root of
arrows.

宋鈺 Kori Song

cargocollective.com/korisong

Kori Song宋鈺，自由插畫師，畢業於四川美術學院，現居香港。香港插畫師協會專業會員。喜歡繪本及故事書創作；為了方便三十年後的自己回憶過去，決定要將那些人生中特別的人和事，畫和寫下來。2013年憑第四屆年輕作家創作比賽 出版首本繪本集《知了》。相續出版兒童繪本《The Swimmers》、《Found in Hong Kong》。

Kori Song is a Freelance illustrator lives in Hong Kong. graduated from Sichuan Fine Arts Institute, Hong Kong Society of illustrator Full Member. Kori's first book, Cicada, was a Winner in the Sun Hung Kai Properties Young Writers' Debut Competition in 2013. A picture book, The Swimmers, published in 2014. Found in Hong Kong , published in 2015.

⌂ *Flat 3203 Block C, Kam Lung Crt, Ma ON Shan, N.T. Hong Kong*
✉ *kori.song@gmail.com*

這是我的北疆之旅，第一次去新疆就愛上這個美麗的地方。夏天的野花，山間的清晨，荒蕪的邊陲小鎮，沙漠、風車、蒲公英……在大自然面前我是那麼渺小而自由。

This is my first trip to Northern Xinjiang, and I'm already in love with this place. Wildflowers blooming in summer, the morning sun in the valley, the small village on the edge of nowhere; desert, windmills, dandelions...we are so small and yet so free in the nature.

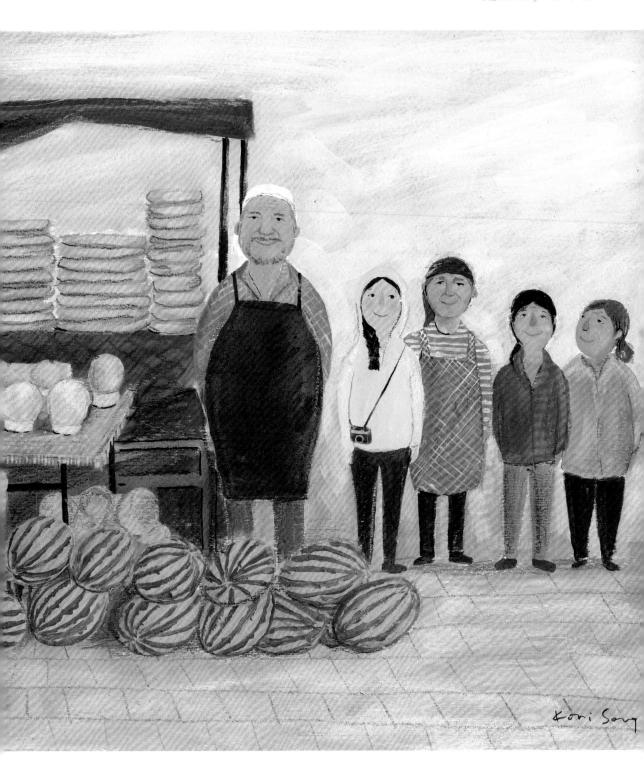

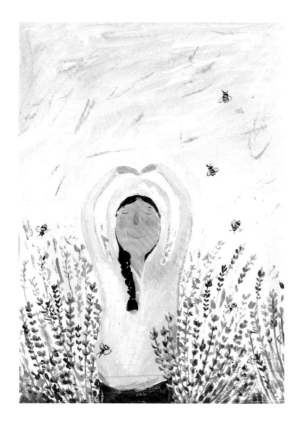

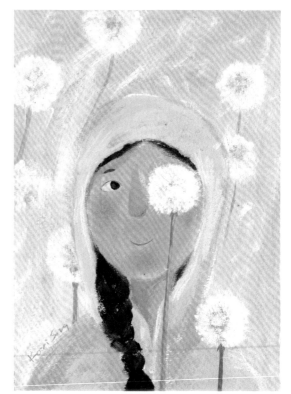

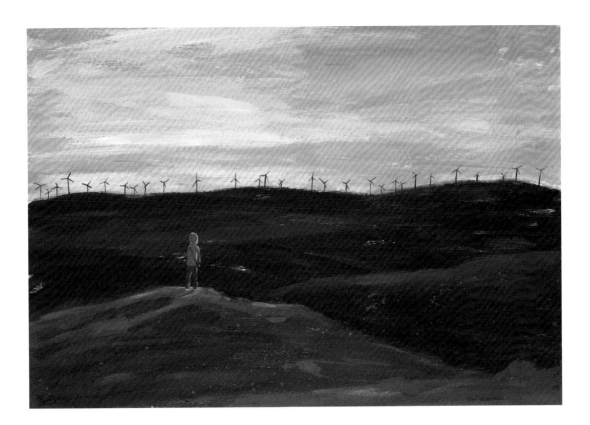

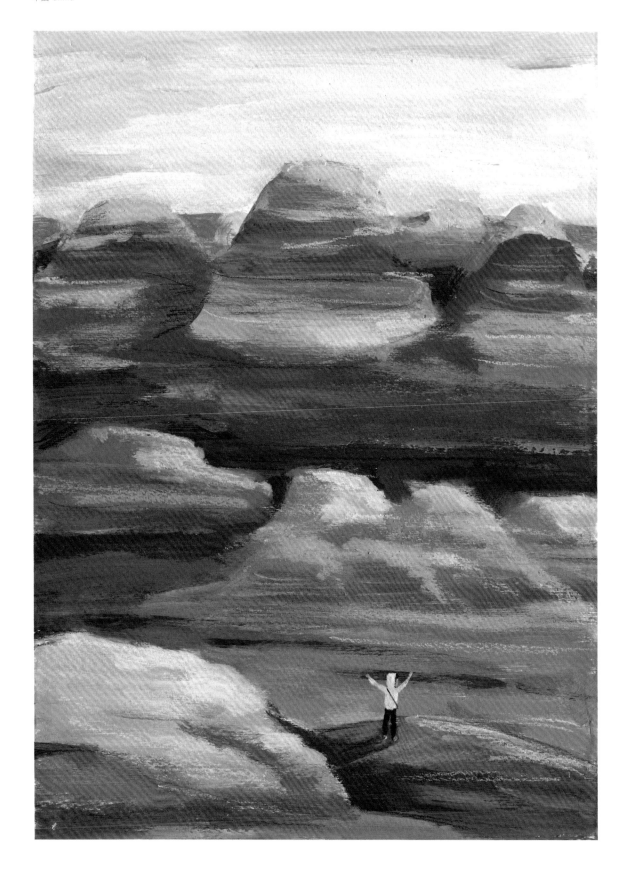

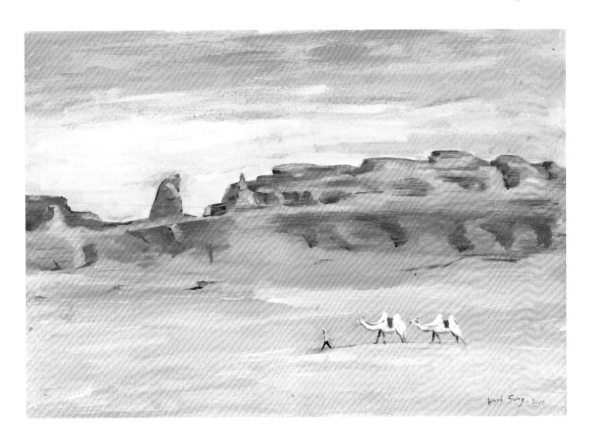

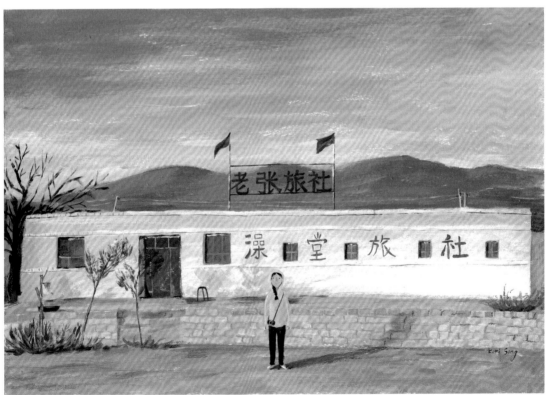

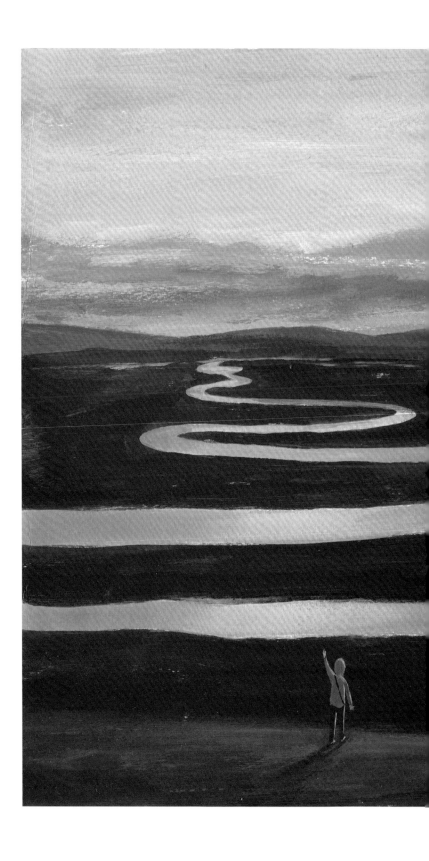

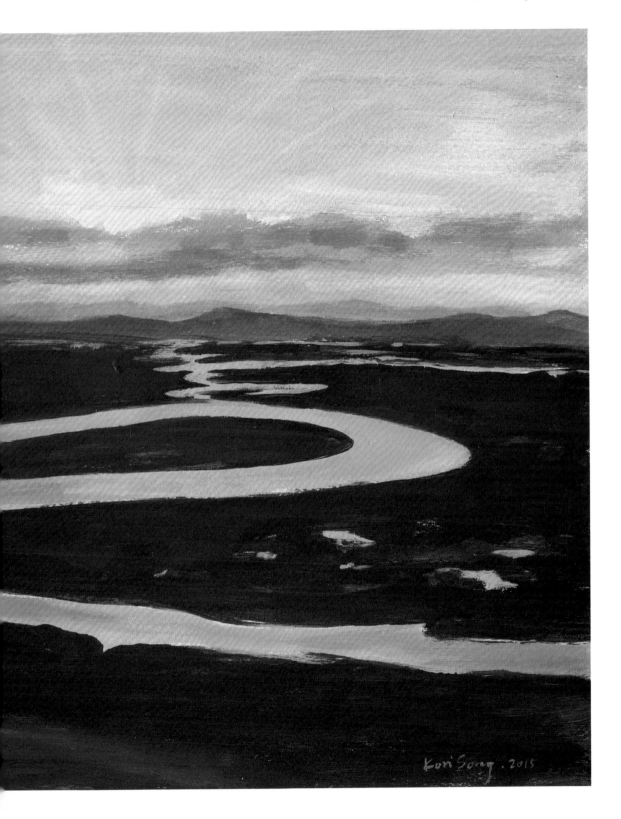

鄭穎熙 Amimi Cheng

www.amimicheng.com

來自香港的Amimi，曾於香港、美國、加拿大、中國及台灣參與聯展，其插畫作品被收錄於加拿大Applied Arts Magazine、中東科威特Bazaar Magazine及《亞洲青年創作集錄》。2013年獲邀於AAD亞洲創意交流設計師講座及高雄設計節「設計學堂」擔任講者。

生活在香港這個繁忙和多元化的都市裡，人與人之間的交流、感情、喜怒哀樂和日常發生的事情也能成為她的靈感來源，引發她觀察和思考生活裡的每個小細節，以畫筆呈現出來，希望透過作品去啟發他人和增強人與人之間的聯繫。

Hong Kong based illustrator, Amimi has showcased her works in various exhibitions in Hong Kong, US, Canada, China and Taiwan. Her work appears in a selection of publications such as Canada's Applied Arts Magazine, Kuwait's Bazaar Magazine and APPortfolio. Amimi was invited to be a speaker at Asia Visual Art & Design Exhibition 2013 and Kaohsiung Design Festival 2013.

Amimi's works are often inspired by personal experiences, interactions and behaviors between people, which have captivated her to be observant to the surroundings. Through her works, she hopes to convey her artistic passion to help
establish and to form a connection between herself and her audience.

✉ *amimicheng@gmail.com*

《緣》 每個人也有自己的獨特故事，而我把每個人的小故事在畫紙上串聯在一起，一個一個描繪出來，就像一個小社區一樣，充滿特色與驚喜。

《Circle of Stories》 Each person has their unique stories and personalities, and I drew everyone together to form a surprising community.

Amimi Cheng

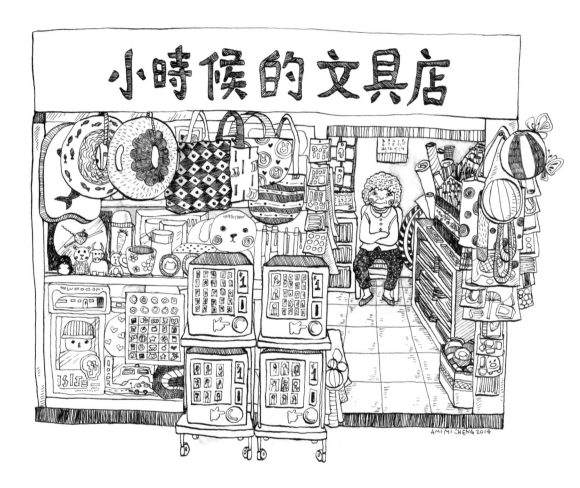

1 | 2

1.《小時候的文具店》小時候最喜歡逛文具店，個子小小的我進入店裡，感覺有如在尋寶箱裡面，找尋喜愛的文具和精品，流連忘返。直到現在，還是會在文具店待上很久，像孩童時候一樣，慢慢挑選，慢慢回憶⋯⋯。 2.《例湯人生》香港的是日例湯為餐廳裡提供的附湯，每天都是不同的。跟朋友在吃飯時聊到：「人生是否就像這碗例湯，都是有人事先預備，口味沒得選擇。」也許，我們從張開眼睛、跌進這個社會裡時已被丟進那鍋湯中，不斷在湯裡浮浮沉沉。但是把它看作地獄裡的熱爐、或是令人身心舒緩的溫泉，就看我們自己如何去調適心境了。

1.《Stationery Store》 Ever since I was a child, I've always enjoyed going to stationery stores. Filled with all sorts of wonders and surprises, stationery stores are like a treasure box of unique stationeries and goods which has filled my childhood memories. 2.《Soup of the Day》 People once said that "Life is like a bowl of soup, everything has already been planned by someone else, there isn't a choice." From the moment we open our eyes we are thrust upon this giant pot, endlessly floating within, but to see this pot as a flaming pool of broth from hell, or a relaxing hot spring, wouldn't that be something to think about?

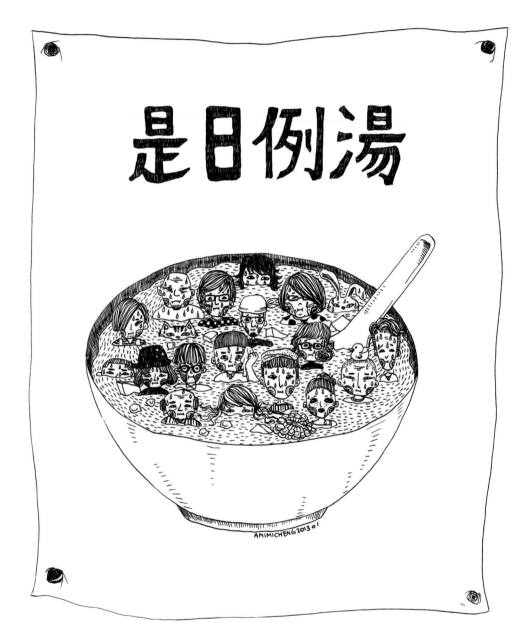

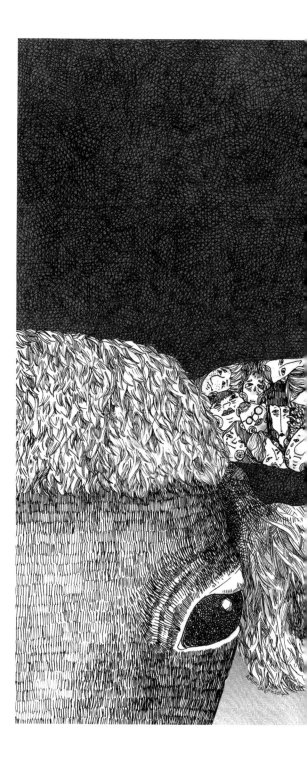

《牛的疑惑》 一隻牛問另一隻牛：這麼多地方可以去，可以選擇，為何他們總喜
歡鑽進我們的角尖裡？

《A Cow's Suspicion》 There's a Chinese saying which roughly translate to "Turning to the tip of a cow's horn". The meaning of this saying is to reflect on how people tend to corner themselves with their own thoughts. In this piece a cow asks another cow "Why do they always go to our horns when there are so many other options?"

1 | 2

1.《冬》緊靠在一起取暖。 2.《秋》人們說秋風起，三蛇肥。我就認為，秋天是特別想睡覺，做大懶蛇的季節。

1.《Winter Time》Huddle together with friends to share the warmth, love and care in the cold weather. 2.《Autumn Time》To me autumn is the best season for sleep.

中秋節快樂
HAPPY MID-AUTUMN FESTIVAL

1 | 2

1.《中秋》與朋友家人相聚一起，享受團圓的幸福感。 2.《帽子派對》設計自己的帽子，一起來參加派對吧！

1.《Happy Mid-Autumn Festival》Unite with friends and families this Mid-Autumn and share the love and joy this festival brings under the full moon night. 2.《The Hat Party》Design your own hat and join the party!

Chow Lee
www.chowlee.com

出生與成長於香港。CHOW自1993年開始插畫與繪
師的生涯，並以多元且強烈的藝術風格知名。主要為
不同的企業、機構、媒體等進行插畫創作與製作。曾
在香港、澳門與上海展出。近期由香港傳藝中心頒發
獲選為2014年十大傑出設計師。

Born & raised in Hong Kong. CHOW started his career
as an illustrator/painter since 1993.
Chow is known for his diversified styles and strong
work ethic. He works together with advertising
companies in brand identity design, packaging, and
magazine cover illustration.
Chow has exhibited in Hong Kong, Macau and
Shanghai. More recently, he was also awarded winner
of the Ten Outstanding Designers Award 2014 by the
Hong Kong Communication Art Centre.

✉ *chowleeill@gmail.com*

《Woman and Child》這系列由三年前創作，描寫女人和小孩，由我單身以至
認識太太，組織家庭，到孩子出生⋯現在我對女人完全改觀。

《Woman and Child》On woman and child, this series has been for three
years. Going through from being a bachelor, meeting my wife, owning our
family to the birth of our child⋯ I now see women from a completely new
perspective.Great!! Thank you

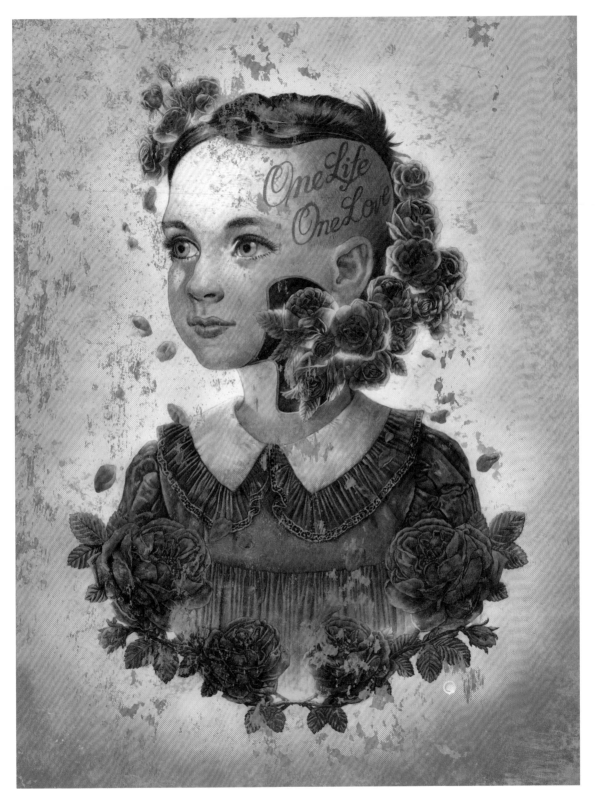

《One life one love》睡在旁邊的人，好像永遠不長大，也希望她永遠長不大。
《One life one love》 She who sleeps next to me, seems would never grow up. I hope she would not grow up forever.

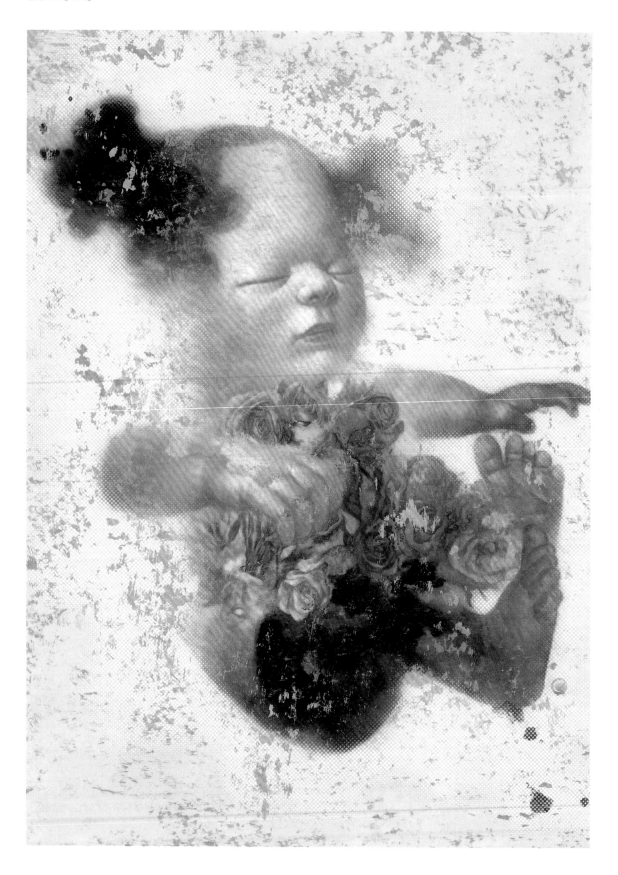

《Learn to be good girl》 望着太太的肚子，幻想着一個小生命日漸成長，每天
掙開眼就像看見自己，模仿一舉一動。由純潔至沾滿泥塵，可能只是數年光景。

《Learn to be good girl》 My anticipation of the growth of a new life grows
as my wife's tummy gets bigger... a little baby wakes up every day, sees me
and imitates me in every way⋯ From a pure newborn to polluted man of the
world, it might only be in a few years' time.

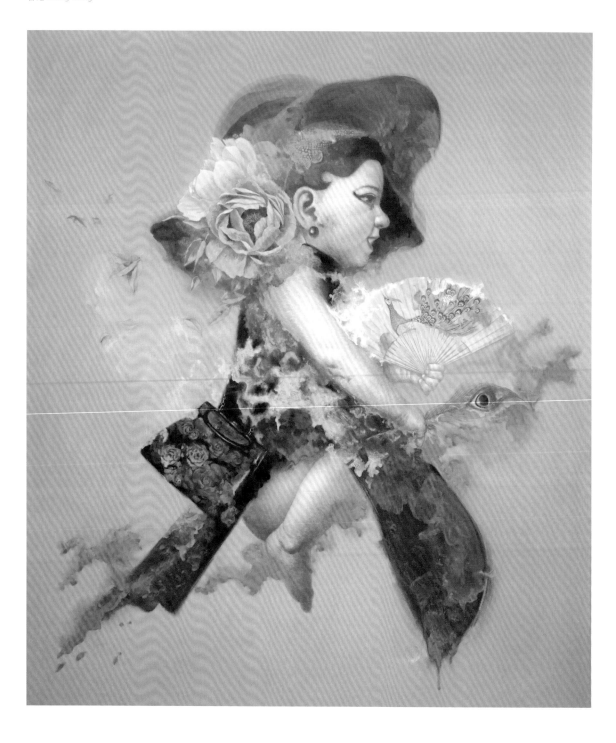

1 | 2

1.《Learn to be 2 》少女的成長期，總要學習不同的社交禮儀。潔淨的外表，有禮的談吐。不知道是否生存之道，仿佛每個人的內心就被華麗外表覆蓋着。2.《Busy》以往覺得女人最終的事業，就是結婚，成家立室。但太太告訴我，生孩子只是第二階段的開始。

1.《Learn to be 2 》A teenager girl must go through the learning process of different social etiquette. She puts on a sharp outlook and polite conversation. C'est la vie? Her true nature is all covered up by a gorgeous appearance. 2.《Busy》I used to think a woman's final career is marriage and family. However, my wife told me that giving birth to a baby only opens up the second stage…

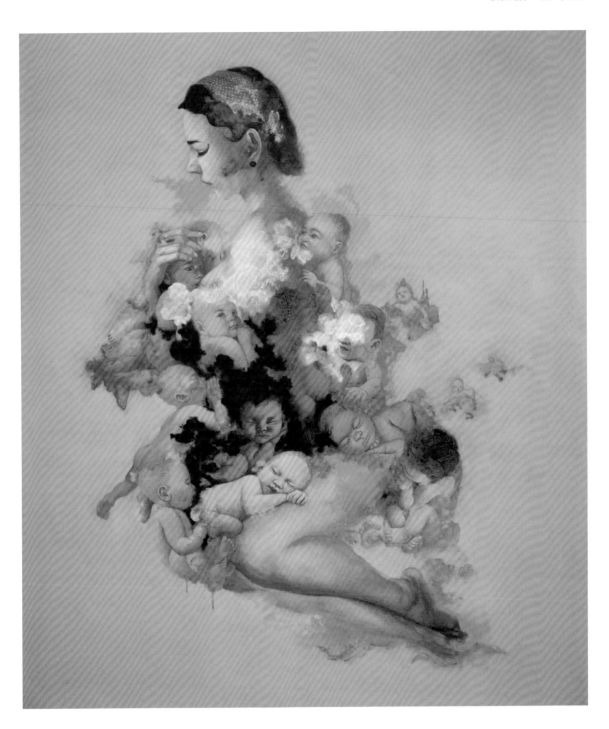

Garnet Chu

www.facebook.com/garnetchu.illustration

對於一個鍾愛美術及設計的一個香港人，對琳瑯滿目的美學都需要持有興趣，在美學及創作這種態度便不會存有對錯之分。Garnet便有著座右銘「只要不是犯法，什麼都可以試」，更希望有一種實驗性美學者的操守。不論傳統顏料到現代的數碼技巧都會運用。他認為直覺及不經意的繪畫是傳遞人與人之間情感的最佳途徑，也能盡情真實面對自己追求的感受。

For a Hong Konger who loves arts and design, there should be no right or wrong in creativity as long as he keeps an open mind in the study of aesthetics. No matter whether it's looking at something new, or studying different styles or techniques, Garnet has the same motto: "You can try anything, as long as it's not illegal". He hopes to maintain the ethics and integrity of an experimental aesthetics artist.

⌂ *香港新界*
✉ *garnetchu@gmail.com*

1.《十一月的實驗（十號）》 雖然「感覺」是很抽象又很虛無，但我們可以合上眼用心去感受，幸好還可以在數碼世界用上不同的技法；暢快自由表達；一切都變得有可能！使我感受和靈感一切都如百花盛放源源不絕般美好。 2.《十二月的實驗（十一號）－在終點開始》 2012年末日後的第一張作品。告訴自己該重頭上路了。

1.《NOVEMBER EXPERIMENT_NUMBER 10 - Feel IT》 Although the "feel" is very abstract and very nothingness, But We can close your eyes and heart to feel, Fortunately, in the digital world, I can spend in different technique; freedom of expression; everything becomes possible! Make me feel everything and inspiration like flowers bloom. 2.《DECEMBER EXPERIMENT_NUMBER 11 - Starting at the end》 The First Work After 2012 Judgment Day, Tell myself back on the road.

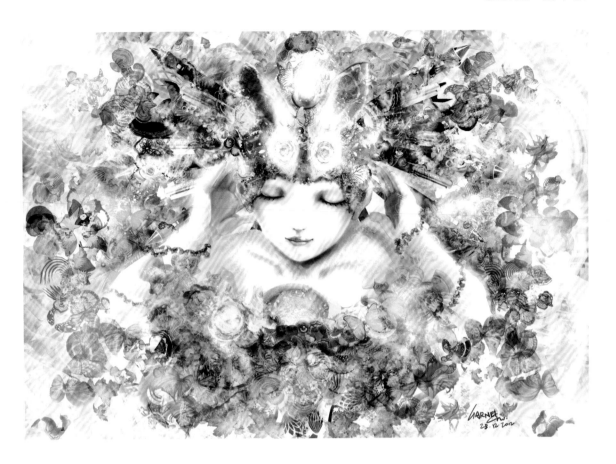

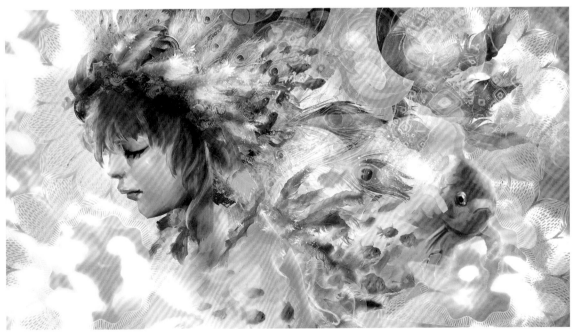

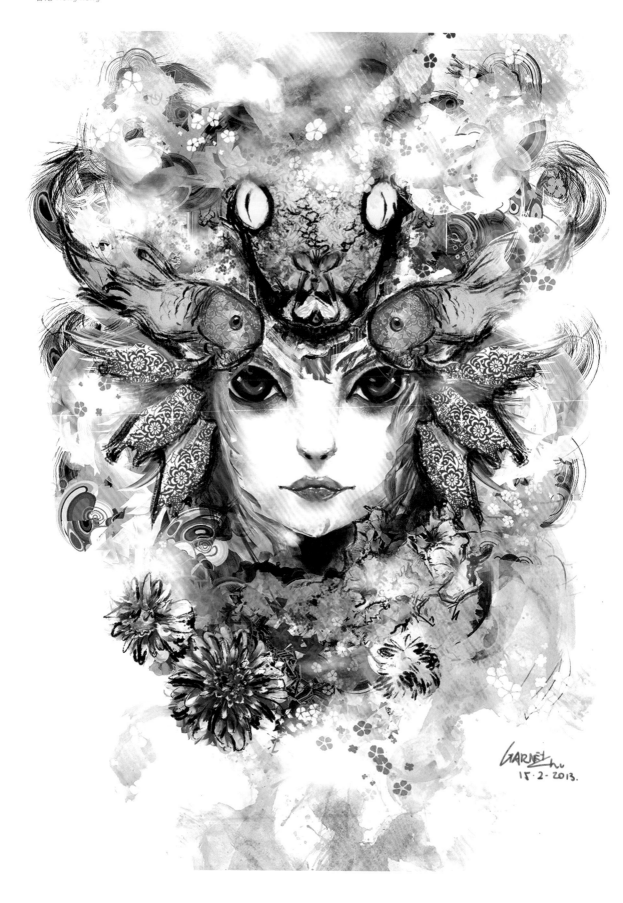

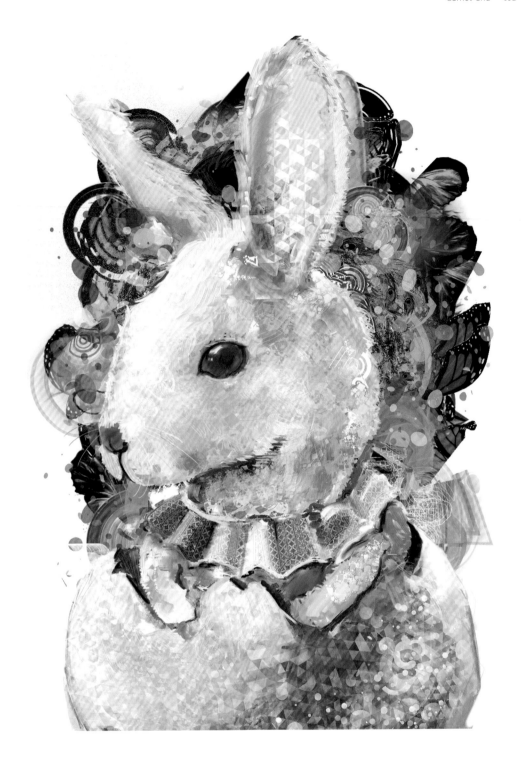

1 | 2

1.《一月的實驗（十二號）－蛇》 蛇年的到來。我用畫畫的方式去紀錄二十四的我，第三個蛇年。 2.《三月的實驗（十三號）－復活小兔》 復活節不一定代表耶穌。我從中也令到自己繪畫的感受復活起來。

1.《JANUARY EXPERIMENT_NUMBER 12 – Snake》 Snake's arrival.I used paint to recorded my twenty-four years old, and the third Year of the Snake.
2.《March EXPERIMENT_NUMBER 13 - Easter Bunny》 Easter does not necessarily represent Jesus. I also made to feel from their own painting resurrection.

1.《∞ illimited》從實驗中，我找到了自我。我希望能擁有貓頭鷹的靈性和智慧。在無限的畫紙世界，無邊無際的飛翔。　2.《十月的小貓》這一年我認識了藝術家的好朋友。小貓總是能治癒心靈。

1.《∞ illimited》I found myself from the experiment, I wish I owned the owl spirituality and wisdom. Fly In the infinite world of paper. 2.《October kitten》This year I know the artist's friends. Kitten always can heal my soul.

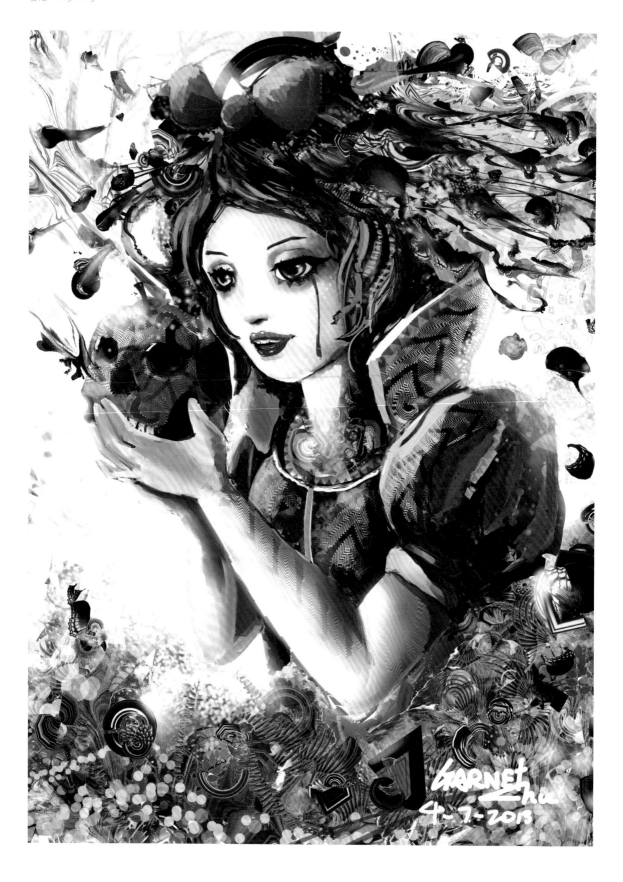

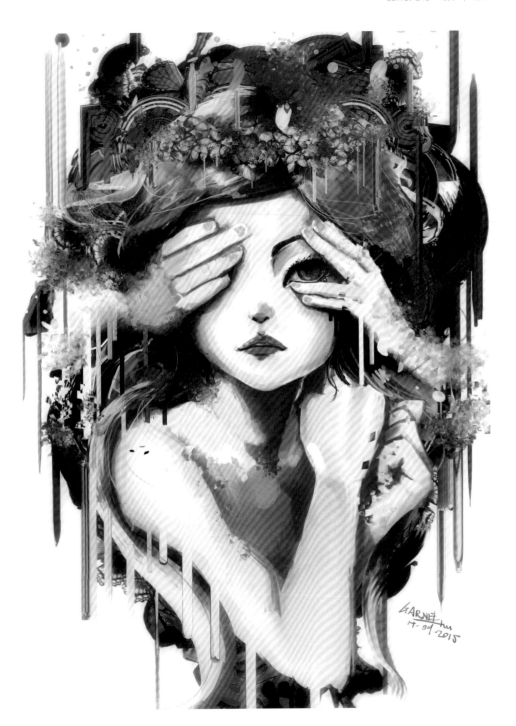

1 | 2

1.《白雪》 在小時候覺得「白雪」她是美貌，健康，純真。當我長大後，懂的字多了，再細閱通行版的格林童話，卻覺得故事結局原意是帶出如此令人驚慄。我再一次把心中對白雪的印象再演繹的同時，不禁反思：是夢幻的白雪藏著現實真相；還是世界塗污了兒時的童真？ 2.《第一定律》 我放下了畫筆接近了一年時間，去體會不同的事物。再次執筆的時候不再是實驗了。我發現這些生活的感覺成為了一種定律。

1.《SnowWhite》When I was young, I think that "Snow White" She is beauty, health, justice, innocence. When I grow up, I understand more words, and then read the Prevailing version of the Brothers Grimm, I can't believe that the ending is a Horror Story. II re-interpretation "Snow White" of my mind, I rethinking Is the snow hidden the truth; or the world's smear innocence? 2.《1st Law》 I had been put down drawing close to a year, and i go to experience different things. But this time is not experiment. Because I found that the feeling become a Law.

Miloza Ma
milozama.com

Miloza 現為香港插畫師及角色設計師。2010年成立個人品牌 Brain Child 後，令業內人仕關注並開始與不同的創作單位合作。於 2013年舉辦了一個小型的畫展後，便全身投入個人創作，發展個人的藝術事業。
現主要為客戶提供設計及插圖方案。
現時每天都沉溺在創作當中，每天都在畫，的確是很自在。在日間畫畫，想的概念更能實踐起來，不用每天只是發白日夢，而是確切的行動，令我在這半年間做出我未曾做過的創作，如繪畫大型的畫作，這是我一生都沒想過要實踐的事情。

Miloza is an illustrator and character designer based in Hong Kong. As a child, she drew inspiration from the patterns she saw while staring at the wall. Now, through drawing, she brings these odd creatures to life. Her works carry a surrealist nature. After establishing the Brain Child brand in 2010, she earned recognition and began collaborating with various artists. A mini-exhibition in 2013 marked the beginning of a full-time devotion to creating her personal works as she embarks on her own artistic career.
These days, I spend every day drawing. I feel fortunate to be able to draw during the daytime, turning my daydreams into reality. In the past half-year, I made a personal breakthrough by producing large-size paintings, something I never thought I would be able to do.

⌂ *Flat H 11/F, Wang Kwong Industrial Building,45 Hung To Road, Kwun Tong, Kowloon, HK*
✉ *milozama@rocketmail.com*

《Freedom Of Mind》以自由意志，帶同玩伴超越現實的邊界，走進一個未知的領域，開始探索人生的自由。

《Freedom Of Mind》Once my mind is free, I start the journey of enlightenment with my playmates. Together we trespass the boundary of reality and enter the uncharted region. Our search for the real meaning of freedom begins.

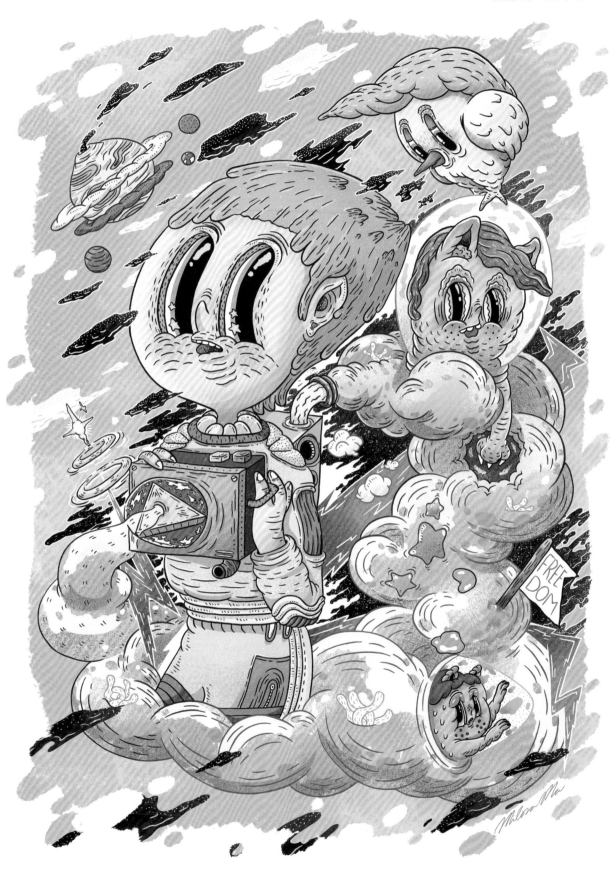

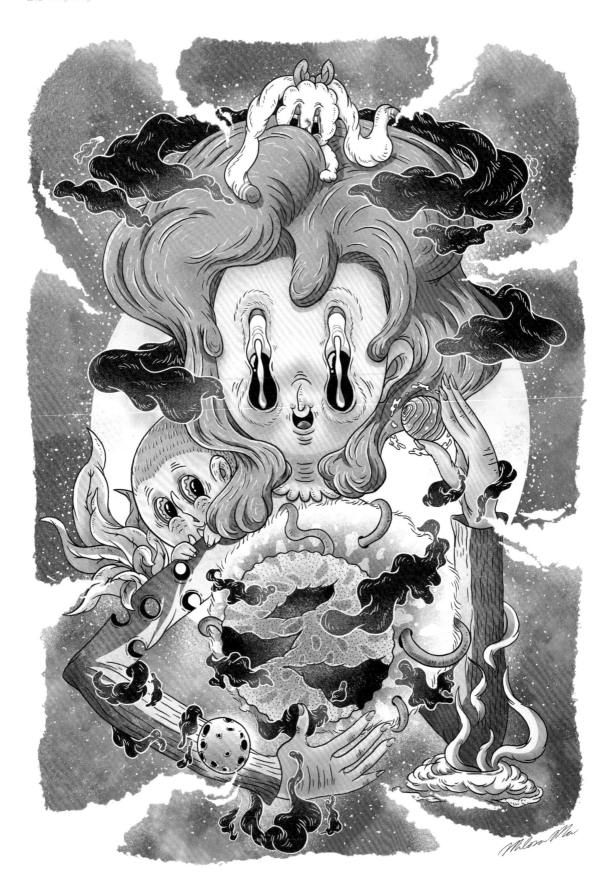

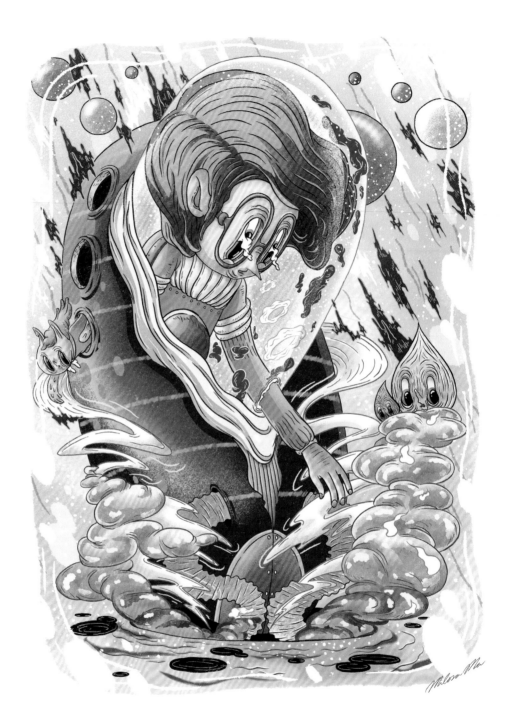

1 | 2

1.《Event Horizon》黑洞的凹凸早已成為生命的存源，使者利用靈修的力量將
存源重新整頓，開創新的銀河。 2.《USO》太空人坐進 USO 開啟星門通道。

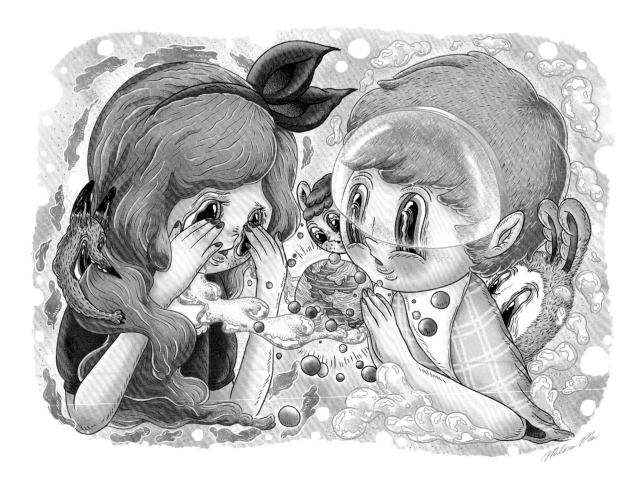

1.《Cosmic Present》 純真小女孩吸引了外星女孩以她的淚水創造成一個屬於她的美麗星球。 2.《The Nine Creators》太空人坐進USO開啟星門通道。

1.《Cosmic Present》 With the help of the girl from outer space, an innocent girl's tears is transformed into a stunningly beautiful planet. 2.《The Nine Creators》 A new galaxy is born as the nine gods join forces and create the nine planets.

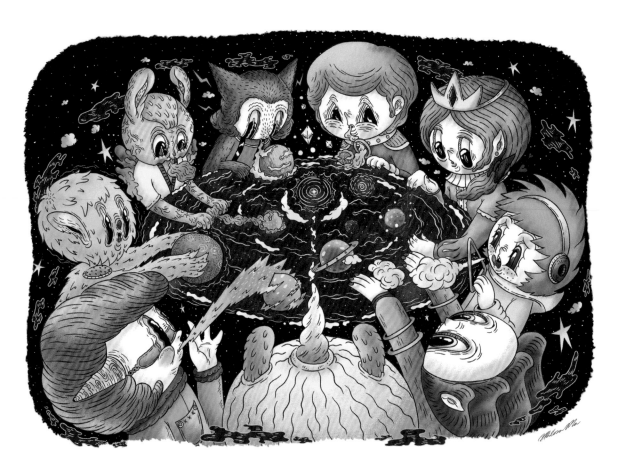

Abiyasa Adiguna Legawa

behance.net/abiyasaadiguna

插畫家/視覺設計師 位於印尼萬隆，十分講究於作品
細節，以色彩、線條、點狀、形狀與組合創作多數插
畫作品，創作靈感多受日常生活的平凡事物啟發。

Illustrator/graphic designer based in Bandung,
Indonesia who has an obsession with details in
his work, creates mostly vector-based illustrations
exploring colors, lines, dots, shapes and composition,
inspired by various simple things in everyday life.

⌂ *Griya Bukit Mas II*
✉ *abiyasaadiguna@gmail.com*

《Gatotkaca》 Gatotkaca，摩訶婆羅中擁有神力（如飛天）、並擁有「otot
kawat tulang besi」暱稱（意即骨以鋼而作，肉由鐵而成）的知名角色。儘管擁
有這麼強大的力量，Gatotkaca卻是中心謙卑的角色。

《Gatotkaca》 A visualization of Gatotkaca, a character in the Mahabharata
known for his magical powers such as the ability to fly and is also famous for
his nickname "otot kawat tulang besi" (muscle made of wire and bones made
of steel). Despite all of those powers, Gatotkaca is considered as a very loyal
& humble figure.

1《In Pages》 印尼作家Naomi Arsyad的短篇作品《In Pages》的插圖。描繪那些喜愛奇角色的人們。你並不奇怪,你是個擁有純真心靈的美好人類。

2《Sing》 在獲得我們想要的旅程中,有時候我們需要後退一步,休息一下並哼首歌。誰不喜歡唱歌?我們不需要擁有像碧昂絲或是瑪麗亞凱莉那樣的好歌喉。在前往現實世界中的下一場冒險前,讓心永遠保持新鮮感,看看周圍有什麼,想想你做了多少,並在午夜之時在心中大聲歌唱。

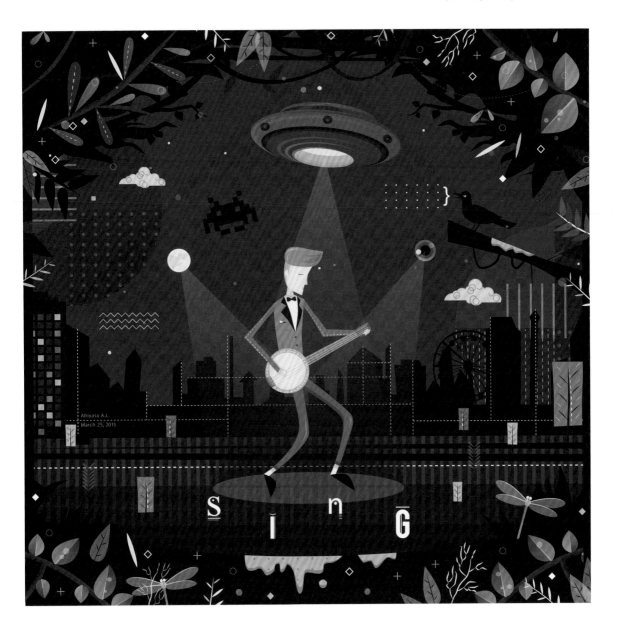

1. 《In Pages》 A visualization of a short story created by Naomi Arsyad entitled "In Pages" that is "dedicated to those who feel some kind of special endearment for fictional characters. You are not weird. You are a wonderful human being with pure heart." 2. 《Sing》 During our journey to reach what we want, sometimes we just need to take a step back, relax a little bit, and sing.

Who doesn't love to sing? You don't need to be Beyonce or Mariah Carey to be able to sing. Keep your mind fresh, look at what is happening around you, evaluate what you've done and just sing what's on your mind out loud in the middle of the night before going back to the real world to fight for your next adventure!

《The City of Colors》 受到珍‧雅各的《偉大城市的誕生與衰亡》一書的啟發，唯有城市由每個人創造之時，城市才可以提供每個人某些東西。於是我畫出理想城市中許多人生活在一起的景象。

《The City of Colors》 The way I visualize the ideal city where many kinds of people from different backgrounds and lifestyles all live together peacefully in a happy, colorful way.

Aditya Pratama
bersama-sarkodit.tumblr.com

Aditya Pratama是印尼插畫家，過去在萬隆市的國家技術學院修讀視覺傳達設計。目前隸屬於Fabula插畫公司。他喜愛以傳統和數位媒體繪畫。他有些作品發表於雜誌、報紙、網站、廣告和書籍。最近一次獲得的獎項為2015年Genkosha插畫集獎（日本）。他也蒐集許多小說和童書。

Aditya Pratama is an Indonesian illustrator who studied Communication Visual Design at National Intitute of Technology, Bandung. Now he affiliated with fabula illustration agency. He enjoys drawing in both traditional and digital media. Some of his works published on magazines, newspapers, website, ads, and books. The most recent received by him is Genkosha Illustration File Award 2015 (Japan). He also collects a lot of fiction and children book.

⌂ *Pepabri Batulawang no 65 blok b rw.09 kecamatan kadungora, kabupaten garut, jawa barat, Indonesia 44153*
✉ *aditya.pratama700@gmail.com*

《British Council Ads（Death）》新加坡British Council的廣告系列。British Council幫你提升你的英文能力。

《British Council Ads（Death）》British Council Singapore ads series. British Council helps you find that word faster by becoming more fluent in english.

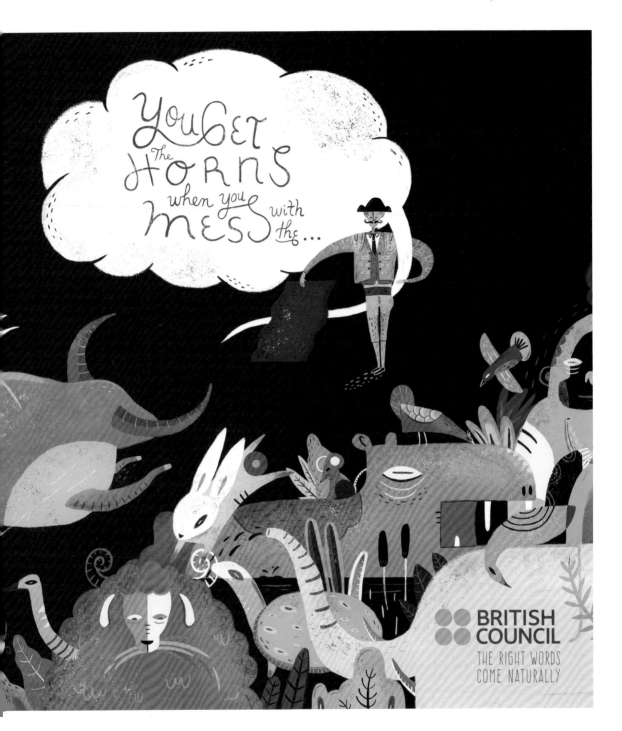

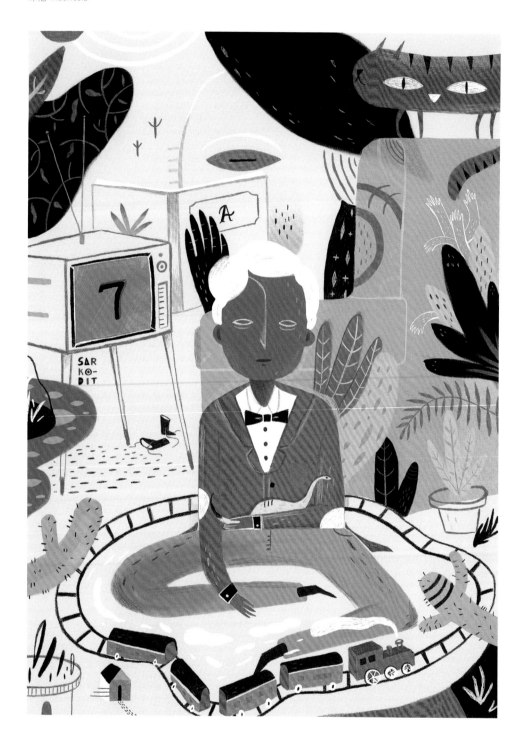

1 | 2

1.《LLE Indonesia blanknote cover》 2015年4月 ELLE 雜誌印尼版歡慶7周年。7本系列空白筆記本由以下視覺藝術家設計：Eko Bintang、Agra Satria、Andhika Muksin、Ykha Amelz、Kims、Lala Bohang 與 我。 2.《flavours magazine》 馬來西亞特色美食與生活雜誌。這篇故事在介紹發酵飲料，像是酵素、奶酒以及發酵茶。

1.《LLE Indonesia blanknote cover》 Celebrating 7th anniversary, ELLE Indonesia Magazine April 2015 issue come up with 7 collectible blank note designs from 7 visual artist : Eko Bintang, Agra Satria, Andhika Muksin, Ykha Amelz, Kims, Lala Bohang and myself. 2.《flavours magazine》 Flavours magazine is a Malaysia food and lifestyle magazine. This pages story write up about the fermentation drinks. Such as enzyme, Kefir drinks, and Kombucha.

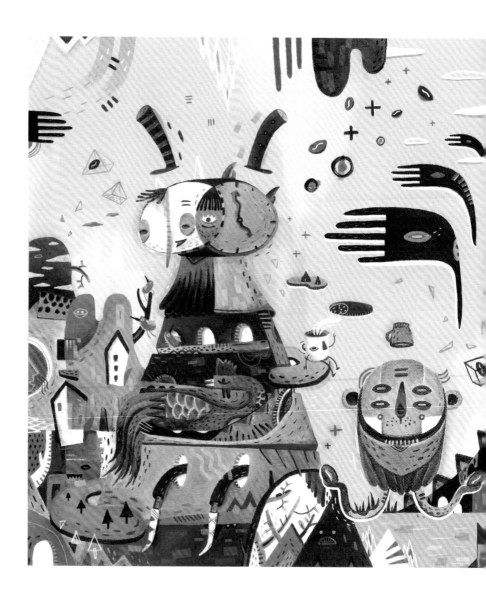

《kemang art and coffee festival》 印尼咖啡與藝術節的插畫。這個插畫告訴
你可以從早中晚隨時喝咖啡。這三個時段代表三個我創作的角色。

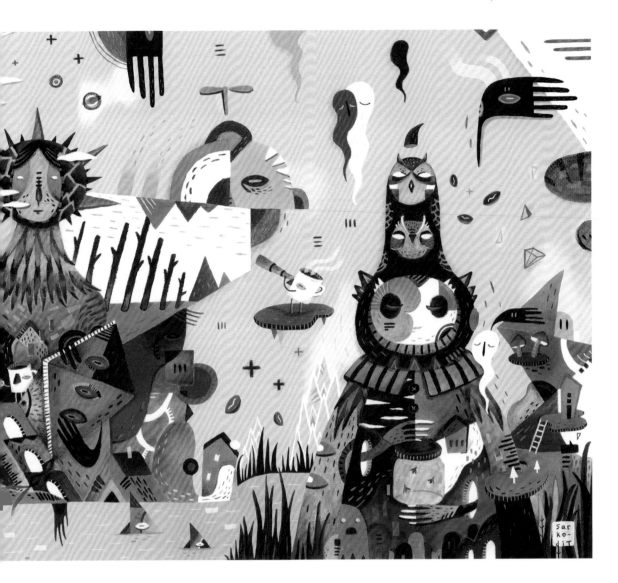

《kemang art and coffee festival》 Illustration for coffee and art festival in Indonesia. The illustration tell s that you can drink coffee anytime. Including in the morning, afternoon and night time. Those periods is represented by the three characters I made.

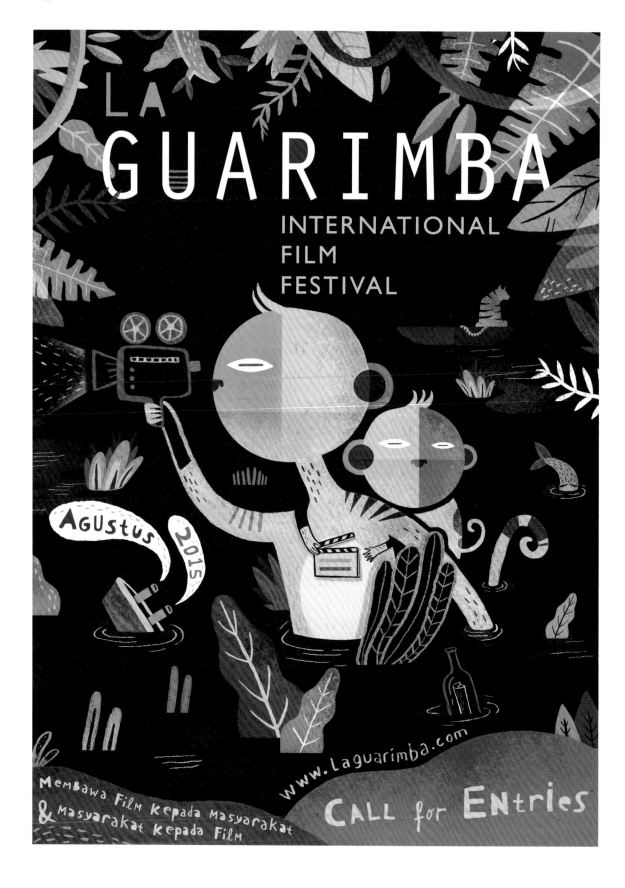

1 | 2

1.《La Guarimba poster》南義大利電影節的計畫。來自世界各地的30位插畫家為這次的影展設計自己的海報，而我獲選為印尼代表。我海報的靈感來自關於海洋的經典電影，像是《鐵達尼號》、《少年Pi的奇幻漂流》。 2.《La Peste Magazine》為《La Peste》雜誌繪製的法國哲學家米歇·翁福雷的詩選。這個議題有關身體題材。

1.《La Guarimba poster》This project made as a part of La Guarimba film festival promotion in Italy. 30 illustrators from different countries made a poster with their own version for this event and I have chosen to represent Indonesia country. The idea of my poster version came from many iconic movies with ocean setting like Titanic and Life of Pi. 2.《La Peste Magazine》 illustration for a series of haikus written by french philosopher Michel Onfray on La Peste magazine. This issue have the theme of Body.

1 | 2

1.《one short story》 與作家的個人計畫。故事是關於由水火化身的生物，藉由叢林的背景設定，我希望這個故事讀起來像首詩。 2.《Rabbit Hunter》 由插畫部與藝術家共同合作出版的藝術書部分內容。每位參與的插畫家繪製自己風格的兔子。這個故事描繪了逃離獵人的兔子。

1.《one short story》 This is my personal project with a writer. The story is about a creature that made from fire and water. With a jungle setting, I try to portray the story like a poem. 2.《USO》 This work is a part of an artbook for the illustration agency's that the designers work with. Every illustrator in this agency make a rabbit illustration in their own version and imagination. This artwork shows rabbits running and try to escape from the hunters.

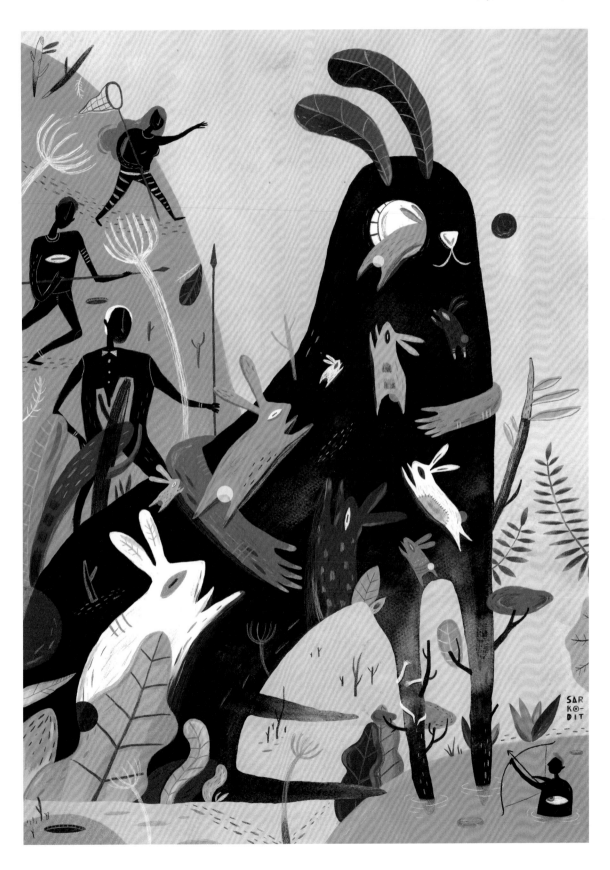

Elicia Edijanto
www.behance.net/eliciaedijanto

我嘗試運用簡約的黑白水彩來創作兒童與動物之間的
獨特關係，以強調場景的心境。我的作品通常描繪幼
小、脆弱的兒童與大象、狼群與熊為伍的樣子。同時
提醒人類與自然間的關係是何等美好，並希望人們在
觀看我的作品時可以獲得平靜。

I try to create a unique relationship between children
and animal with simple black and white watercolor
to emphasise the mood of the scene. My arts depict
small, vulnerable children alongside creatures of
the wild like elephants, wolves and bears Besides to
remind people of how beautiful the relationship of
human and nature are supposed to be, I also want
people to feel the tranquility while looking at my
paintings.

⌂ *Sutera Palma XVI No. 5, Alam Sutera, Tangerang 15326,*
 Indonesia.
✉ *eliciaedijanto@gmail.com*

带出動物與人類關係議題的水彩畫作。
Watercolour paintings that brings out the issue of relationship
between animal and human.

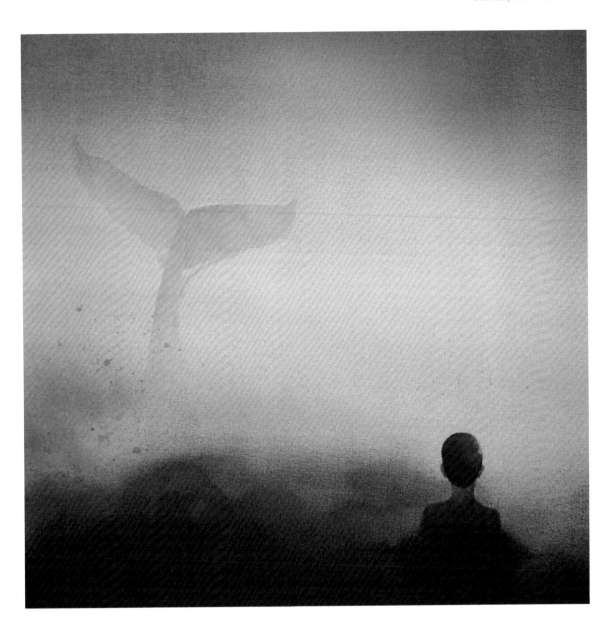

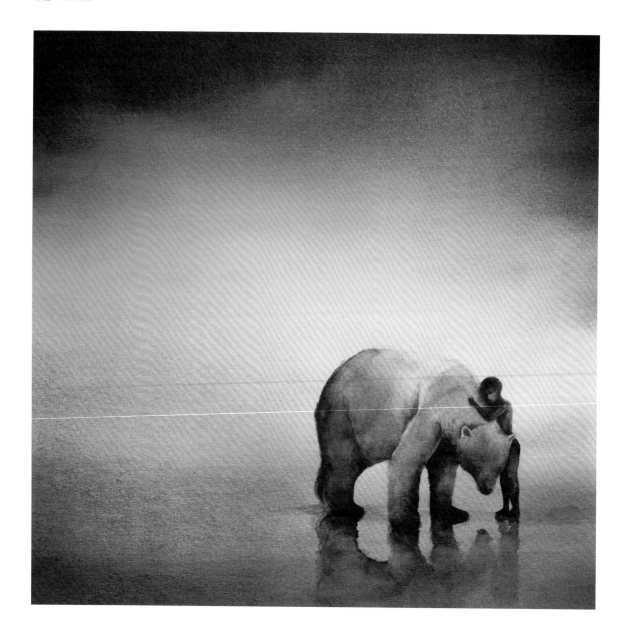

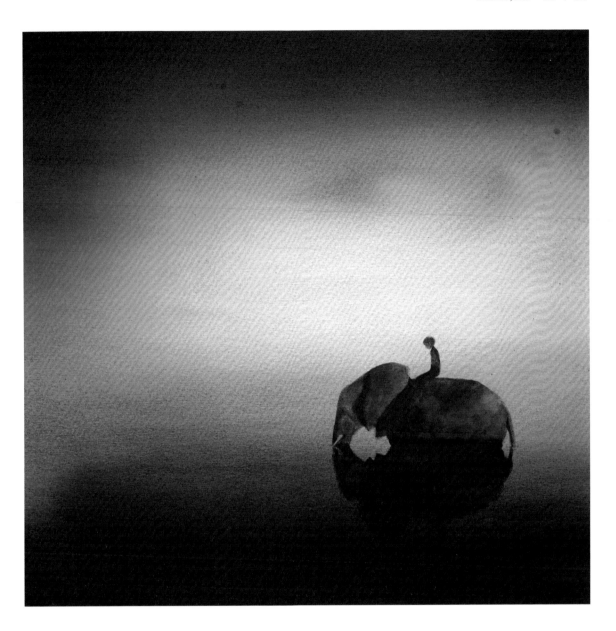

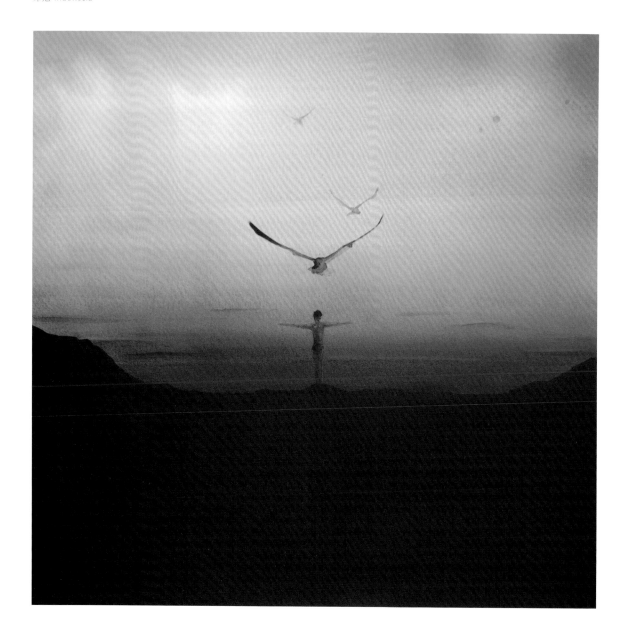

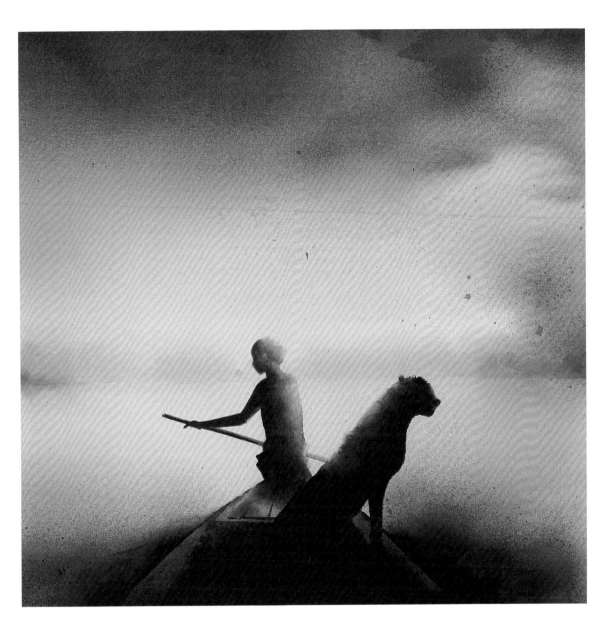

Evan Raditya Pratomo
www.behance.net/evanrp

Evan，印尼插畫家。以Papercaptain聞名於東西合璧的藝術形式創造別具特色的宇宙。2011年以童書插畫家開始事業。現為獨立視覺藝術家。喜歡探索與嘗試多元藝術形式。他是第一位收邀參加 Adobe Photoshop 周年活動的印尼藝術家，並為其25周年設計作品：brave it out。

自幼稚園時，他總夢想自己成為畫家，現在他在創意產業擔任視覺藝術家。希望新進藝術家可以受他的故事啟發。這個故事是關於一個人勇敢地說：我有多變的藝術風格，去學你想學的並不是罪過。儘管大膽的勇敢地去做，因為有一天你會知道你為什麼學它。

插畫家的座右銘：
「風格讓人可以簡單地將藝術分類，但它不需要定義或侷限你。當我看到很酷的事，我會說：哇！真棒，不知道他如何辦到的。我可以做的跟他一樣嗎？」

⌂ *Pondok Blimbing Indah Tama 63 blok E1 no.9, Malang, Jawa Timur, Indonesia*
✉ *evanpratomo@gmail.com*

Evan, an independent visual artist from Indonesia, known for his characteristic universe through the name Papercaptain for creating a wondrous art from the fusion of European & Japanese style. He's the first Indonesian artist to create an artwork on Adobe Photoshop 25 year's campaign. He was also invited to be a speaker representing Indonesian youth literacy during Leipzig Book Fair Festival 2015 in Lipzig, Germany.

He has always dreamed to be painter since kindergarten and now he's a visual artist in creative industry. He hopes young artist can be inspired by his story, the story about a man brave enough to say, "I have various art styles and it's not a sin to learn what you want to learn. Just be bold and brave it out, because someday you will understand why you learned it."

Some of his quotes about his life as an illustrator:
"Style is a way for people to easily categorize art, but it doesn't have to define or limit you. When I see something really cool, I will say, Whoa! That's wonderful, I have no idea how she/he created it. Can I make something like that?"

《WORK THIS BODY》這個作品是關於我的運動的嗜好。我必須要運動，因為我一整天都坐著，而且要活得長久的畫，身體要動。

《WORK THIS BODY》This artwork is visual image about my workout hobby. I have to do it, because I sit a whole day to draw and this body needs to work because I want to be healthy and live a long life.

PAPERCAPTAIN STUDIO'S
THE SOUL OF RABBIT ISLAND

ウサギ島の魂

昔の魂の声から
この島の跡継ぎに。

1 | 2

1.《USAGI JIMA NO TAMASHII》「兔島の魂」意為「兔島之魂」，這個作品受到位於日本廣島的大久野島上的故事啟發。這座島上秘密存在著日軍，並在1927年用來發展生化武器。 2.《MY BIRTHPLACE》這個作品是關於印尼的愛情故事，養鴨人和他兒子趕鴨回家的情景。其所要傳遞的訊息為：來吧，讓我們回家吧，回到我們一直企盼的家。

1.《USAGI JIMA NO TAMASHII》 Usagi Jima no Tamashii which means "The Soul of Rabbit Island", inspired by the story Okunashima island located in Hiroshima prefecture, Japan. This island existence was secretly kept by the Japanese military and used as the basis for the development of biological weapons around 1927. 2.《MY BIRTHPLACE》 An illustration of the Indonesia's romanticism through the figure of dusk breeder and his son, who was about to lead their flocks home. A message from the depiction is, come, let us return to home, a place we have always longed for.

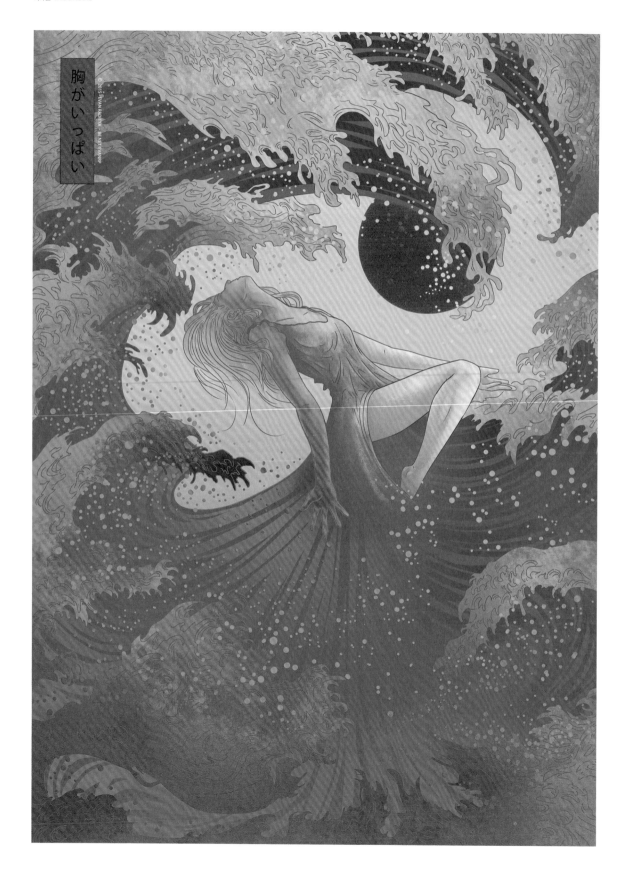

赤い太陽にキス

© 2015 · EVAN RADITYA · BE.NET/EVANRP

1 | 2

1.《FILLED HER LUNGS》這個作品事在我憤怒的時候所作。我大叫，但沒有人聽到，就像你溺水時掙扎的情形一樣。 2.《A KISS FOR RED SUN》我曾夢到一個讓我記憶猶新的夢。在夢裡，我看到驚人且超現實的景色，我看到學校的錦鯉飛越東京，而我鍾情地一直看著他們。

1.《FILLED HER LUNGS》This artwork was born from my rage. I scream but no one heard a thing, exactly just like when you're struggle to survive in drowning. 2.《A KISS FOR RED SUN》I had a lucid dream that inspired me to make this artwork. In my dream, I saw an astonishing and surreal scenery of school of koi fishes, flying above the Tokyo and I endearingly gaze at them.

Putri Febriana
www.behance.net/PutriFebriana

我是印尼雅加達的平面設計師和插畫家。2009 年畢業於印尼坦格朗市希望之光大學（University of Pelita Harapan）視覺傳達設計系。畢業後在雅加達 FullFill Artplication、DesignLab 和 Kineto Strategic Visual Communication 等許多設計公司擔任全職的平面設計師。2014 年 8 月，決定成為自由設計師，專門從事配置設計、簡單平面插圖、地圖和視覺資訊圖表（infographic）。

I am a Graphic Designer & Illustrator based in Jakarta, Indonesia. I was graduated from Visual of Communication Design of University of Pelita Harapan, Indonesia on 2009. After I graduated, I worked as a full time Graphic Designer for several graphic design agency in Jakarta. At the end of 2014, I decided to be self-employed, developing my own style and focusing on simple flat Illustration, maps, layout design and infographic.

⌂ *Jl. Lumut Hijau II F 48-49 Blok L, Kompleks Mega Cinere, Depok 16514 Indonesia*
✉ *febrianaputrii@hotmail.com*

《Crossing the Street on a Rainy Day》這個作品是受到雨天遇到的人所啟發。當時我穿越一個很大的十字路口，從遠方看來，人們身影的色調非常漂亮、許多顏色都融入到這個時刻。

《Crossing the Street on a Rainy Day》I made this artwork inspired by the people who meets together at the same time when crossing a big intersection in a rainy day. They all look like a beautiful pattern when seen from far above, many colors colliding into one big moment.

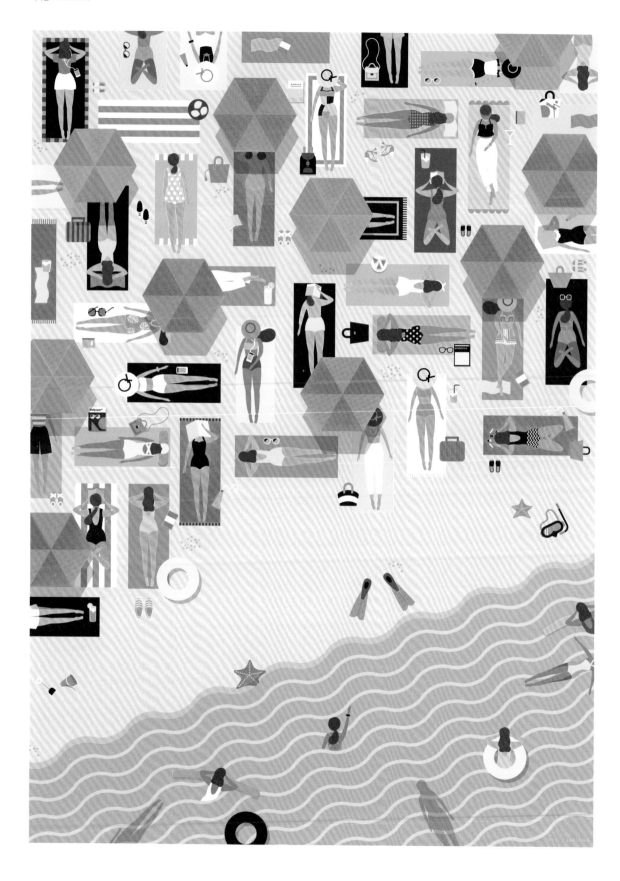

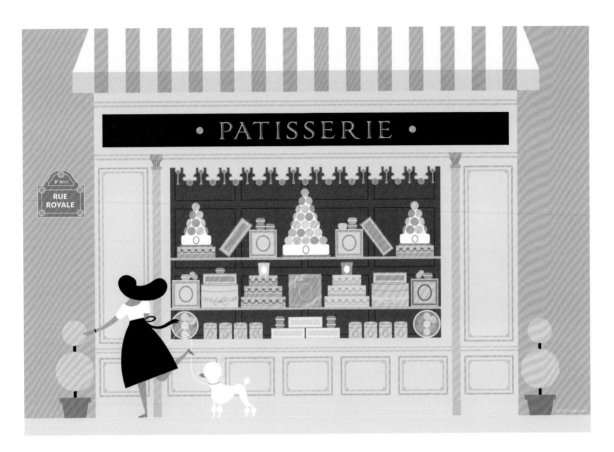

1 | 2

1.《Summertime》作品描述盛夏海灘的環境聲。人們穿上多彩繽紛的比基尼享受盛夏的熱度。在這幅作品中，我試著捕捉人們享受假期的快樂。讓浪花沖刷你的腳、並坐在沙灘上吧！ 2.《Patisserie》 在我第二次去巴黎時，我深深被法國的甜點店── Ladurée Patisserie ──櫥窗內所擺放的甜點所吸引。我去了兩次位於香樹里榭大道以及 Rue Royale 的店，並嘗了他們知名的甜點、馬卡龍以及玫瑰聖歐諾黑。

1.《Summertime》 Describing an ambience of a happy summer season in the beach. People are wearing beautiful and colorful bikinis while enjoying summer heat. In this image, I tried to capture the essence of people happiness who spend their leisure time during holidays. Let the waves hit your feet and the sand be your seat! 2.《Patisserie》 I was mesmerized by the window display of Ladurée Patisserie, a french bakery and sweet maker, on my second trip to Paris. I went twice to their stores at avenue de Champ-Élysées and Rue Royale, and tried their famous pastries, macarons and Saint-Honoré a la rose.

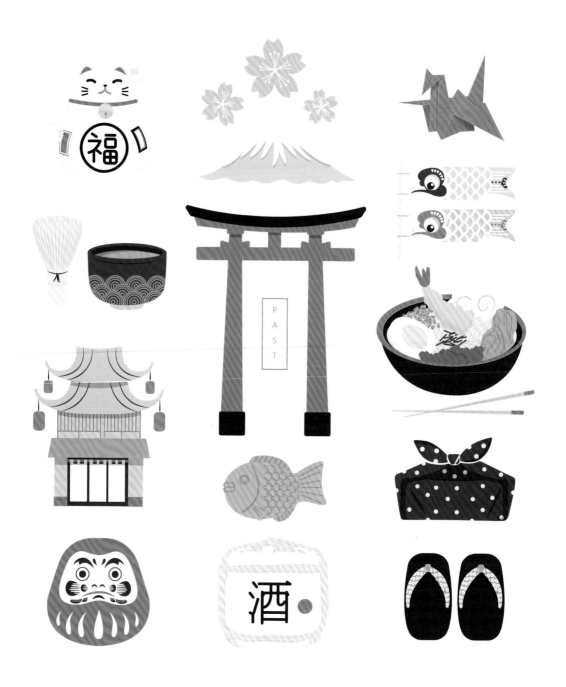

1.《Japan Icons Illustration：Past》兩次不同的時間去感受一國的文化。在這個系列，我試著把日本文化從過去帶到現在。儘管我並未從源頭感受日本文化，這些文化卻深刻影響我國家的日常生活，像是童年的電影與實務。這兩次感受到的差異、以及人們如何發展他們的文化非常吸引人。我認為，文化與生活密不可發。 2.《Japan Icons Illustration：Present》 兩次不同的時間去感受一國的文化。在這個系列，我試著把日本文化從過去帶到現在。儘管我並未從源頭感受日本文化，這些文化卻深刻影響我國家的日常生活，像是童年的電影與實務。這兩次感受到的差異、以及人們如何發展他們的文化非常吸引人。我認為，文化與生活密不可發。

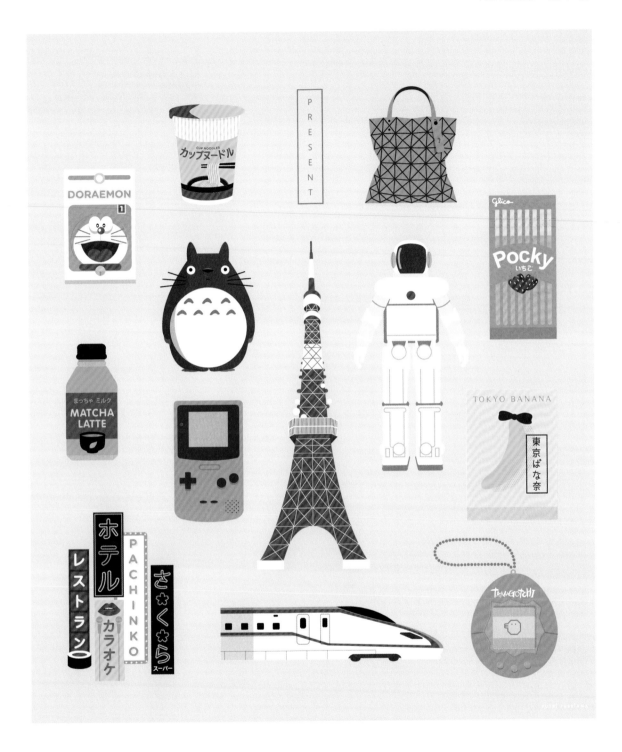

1. 《Japan Icons Illustration : Past》A culture of 1 country in 2 different time. In this illustration series, I tried to bring the Japanese culture from the past and present. Although I'm not experiencing directly from where it is originated, these cultures also effecting in my daily life in my country, for example like my childhood movies and food. I found it attractive to see the differences between these 2 times, how people always develop their cultures. I think cultural and life is a one pulse that can't be separated. 2. 《Japan Icons Illustration : Present》A

culture of 1 country in 2 different time. In this illustration series, I tried to bring the Japanese culture from the past and present. Although I'm not experiencing directly from where it is originated, these cultures also effecting in my daily life in my country, for example like my childhood movies and food. I found it attractive to see the differences between these 2 times, how people always develop their cultures. I think cultural and life is a one pulse that can't be separated.

Sveta Dorosheva

https://www.behance.net/lattona

Sveta，自由插畫家，專職於書籍的敘事性插畫與藝術。

Sveta is a freelance illustrator working in the areas of narrative illustration and art for books.

✉ *sveta.dorosheva@gmail.com*

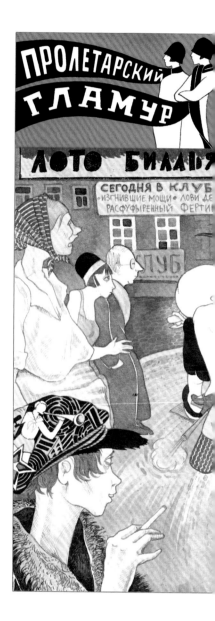

《Proletarian Glamour》「藉由『The Crocodile』雜誌看20世紀歷史」，雜誌插畫。「透過『The Crocodile』雜誌的視角看20世紀的歷史」一共12冊，內容根據蘇聯「The Crocodile」雜誌（1922-1992）的諷刺畫與插畫。這個版本不只要展現長期被遺忘的漫畫與文章，並了解我們成長的世紀、以及改變世界的事件。書中的插圖以華而不實的街景與聳目結舌的宣傳，描繪了蘇聯的生活。每本書收錄了諷刺畫以及雜誌中特定題材的風格畫，如兒童、女人、戰爭、日常生活、流行與時尚。也描畫了1922-1938年無產階級的時尚，人們穿著的方式。

《Proletarian Glamour》 Illustration from "History Through the Eyes of the Crocodile Magazine. XX century". "History of the 20th Century through the Eyes of "The Crocodile" Magazine" is a 12-volume edition that is based on caricatures and sketches from the main Soviet satirical magazine "The Crocodile" (1922-1992). The goal of this edition is not only to show the long forgotten comic images and essays, but also to initiate a serious discussion about the century we grew in and the events that changed the world. The pictures in the archive depict everything in the Soviet life from eye-candy street scenes to eye-popping propaganda. Each book features several galleries of caricatures and genre scenes picked from the magazine's archive and dedicated to a certain topic, for instance - kids, women, war, everyday life, glamour and fashion. This illustration opens the gallery of "proletarian fashions" from the era 1922-1938, dedicated to the way people dressed.

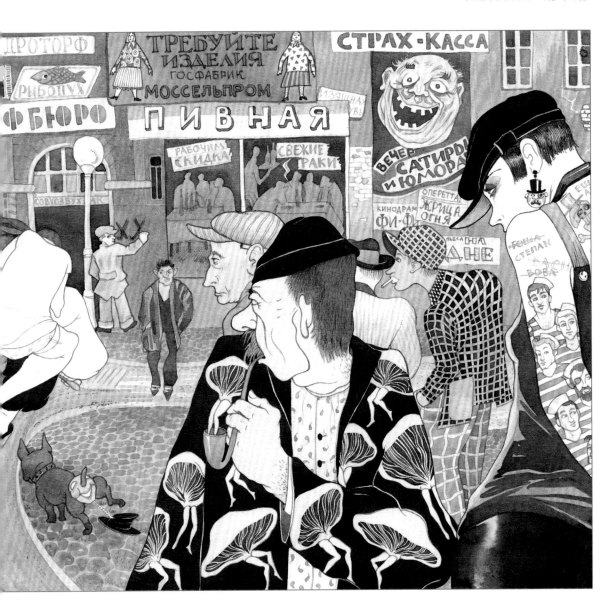

《Hell》「藉由『The Crocodile』雜誌看20世紀歷史」，雜誌插畫。「透過『The Crocodile』雜誌的視角看20世紀的歷史」一共12冊，內容根據蘇聯「The Crocodile」雜誌（1922-1992）的諷刺畫與插畫。這個版本不只要展現長期被遺忘的漫畫與文章，並了解我們成長的世紀、以及改變世界的事件。書中的插圖以華而不實的街景與瞠目結舌的宣傳，描繪了蘇聯的生活。每本書收錄了諷刺畫以及雜誌中特定題材的風格畫。這些插畫揭露了1922至1938年描繪國外的地獄之景。敵人的形象深植於蘇聯的宣傳中。敵人隨著時代而改變，但在這個時期（1922-1938），主要的敵人是來自遠方的傳教士、富農、資本家。

Illustration for "History of the 20th Century through the Eyes of "The Crocodile" Magazine" "History of the 20th Century through the Eyes of "The Crocodile" Magazine" is a 12-volume edition that is based on caricatures and sketches from the main Soviet satirical magazine "The Crocodile" (1922-1992). The goal of this edition is not only to show the long forgotten comic images and essays, but also to initiate a serious discussion about the century we grew in and the events that changed the world. The pictures in the archive depict everything in the Soviet life from eye-candy street scenes to eye-popping propaganda. Each book features several galleries of caricatures and genre scenes picked from the magazine's archive and dedicated to a certain topic. This illustration opens the gallery of authentic drawings from the era 1922-1938, dedicated to hell abroad. Cultivating the image of the enemy was in the heart of the Soviet propaganda. The enemy would change through the decades, but in this timespan (1922-1938) the major enemies were a Priest, a Kulak, and a Capitalist, that lived in a far-far land of Evil.

1 | 2

1.《Blueprint of the Soul》為 Dmitry Deitch 寫的《兇猛聖人》(Ferocious Holyman) 所繪的插圖。 2.《Seeds of Dreams》為 Dmitry Deitch 寫的《兇猛聖人》(Ferocious Holyman) 所繪的插圖。該作品是關於魅魔這個人物,她以男人的夢境為食,以致他兩年不得入睡。

1.《Blueprint of the Soul》illustration from "Ferocious Holyman", written by Dmitry Deitch. 2.《Seeds of Dreams》This illustration is about a succubus wife of a character - she feeds on seeds of his dreams, which is the reason he hasn't slept for two years.

1.《Jewish Street Life》猶太街景速寫。 2.《Hanging the sheets》猶太街景速寫。

1.《Jewish Street Life》 sketches of jewish street life. 2.《Hanging the sheets》 from sketches of jewish street life

1 | 2

1.《Street Market》猶太街景速寫。　2.《Seaside Rendevouz》猶太街景，不同的文化。

1.《Jewish Street Life》 sketches of jewish street life. 2.《Seaside Rendevouz》jewish street life, contrast of cultures.

Aya Kato
www.ayakato.net

我 2004 年開始在國外從事藝術家／插畫家活動。目前
在日本和國外積極參與電視商業、廣告、時尚、室內
設計和書籍等領域。

I began the activity as the artist / illustrator in 2004
around foreign countries. I am active widely now in TV
commercial, advertisement, fashion, interior, books
foreign countries and Japan.

⌂ *305 ALCYONE 157-1 Minamiyama, Komenoki-cho,*
Nisshin-shi, Aichi, Japan 470-0111
✉ *aya@ayakato.net*

《Dress of soul》她閃亮的靈魂如洋裝般展現了自己。
《Dress of soul》Her shining soul, is reflected
as a dress, to represent herself.

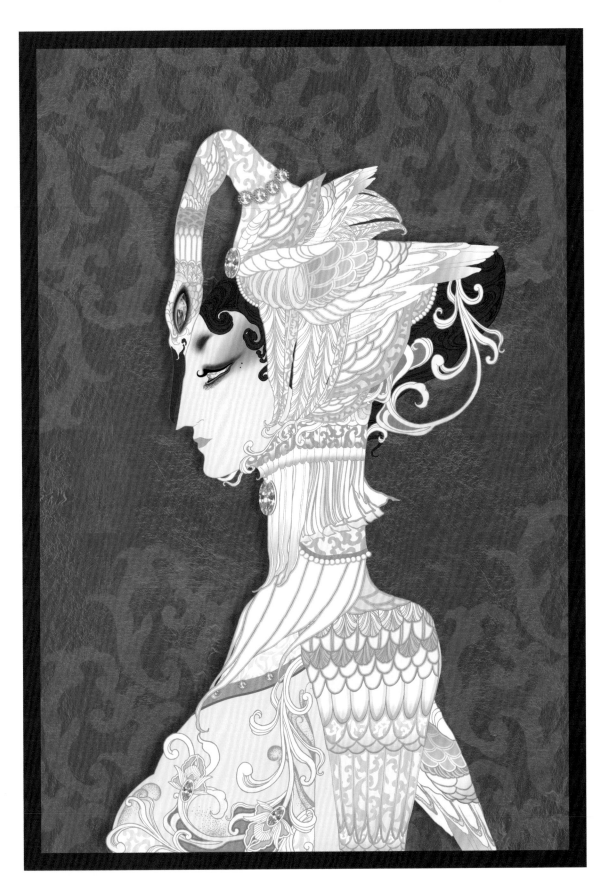

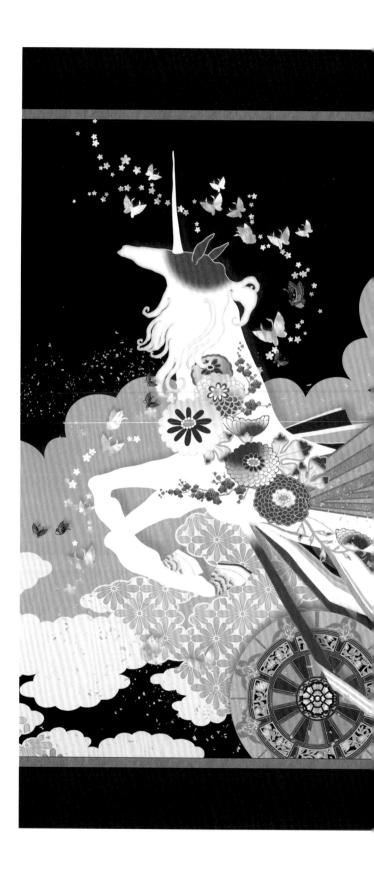

《TSUKUYOMI》月神統治了夜晚。

《TSUKUYOMI》The moon god governing night.

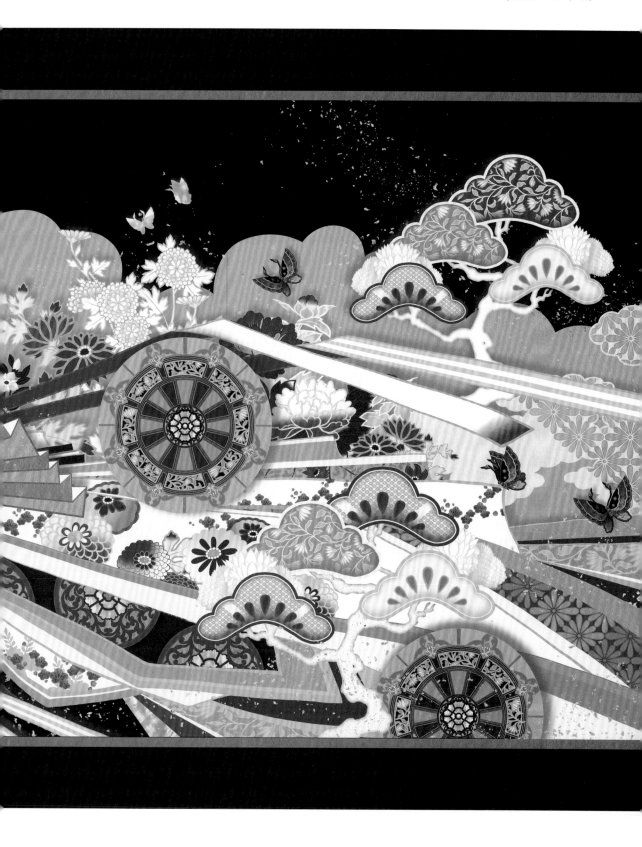

Takehiro Tobinaga
agenthamyak.com/artists/takehiro-tobinaga

TAKEHIRO 住在東京，在日本東京 16 bit 創意公司工作。受音樂、電影和懷舊元素啟發，創作媒材從原子筆、鉛筆到電腦都有。
他充滿活力與色彩的影像近年愈來愈受到國際媒體與客戶的矚目，是藝壇的新星。

TAKEHIRO lives in Tokyo and works in Tokyo, 16 bit, creative company, Japan. He is influenced by music, film and nostalgic material and creates an image from a pen, pencil to computer.
His dynamic and colour of image is recently getting more attention from international media and client, and he is an upcoming artist.

⌂ 新宿區四谷坂町 405, 12-12 Sakamachi, Yotsuya, Shinjuku-ku Tokyo
✉ tobinaga@16bit.co.jp
 info@agenthamyak.com

《OCTPUS》當代音樂可以同時產生許多聲音，但也同時孤獨。
《OCTPUS》 Contemporary music that is able to produce several sounds at the same time alone.

1 | 2

1.《Dynamic Dinosaur》滑板選手必須跨越的障礙。有沒有可能跨越暴龍？
2.《Kumano Kodo Trail》宣傳 Adobe Creative Cloud 活動的作品。我曾去世
界遺產──熊野古道，受該地景色啟發而創作該作品。

1.《Dynamic Dinosaur》A threat that a skater will have to over come. Is it also possible to overcome the T-Rex? 2.《Kumano Kodo Trail》The image for Make it campaign which is a part of Adobe Creative Cloud promotion. I visited the world heritage, Kumano Kodo, and created the image with the inspiration from that place.

1.《MAAI》擁有現代武器的女人。藉由三角形構圖法代表糾結的三方。
2.《Aliens night》電影「異形1」的惡搞作品。化身DJ的工程師機器人，其音樂選集中活躍的異形戰士。

1.《MAAI》 Three women with a modern weapon. On the basic of the triangular composition, representing the entanglement of three. 2.《Aliens night》 Parody work of the movie 'Alien' . Liven up the alien-warrior in the music selection of DJ power loader*.

1.《M's Attack》食物戰爭，來自海外的超強戰力。 2.《Flying machine》超級戰艦伴隨著音樂前往被催毀的世界。

1.《M's Attack》 Food war, a powerful force that has been attached from abroad. 2.《Flying machine》 A huge battleship marches in the devastated world with playing music.

《the Hole Through a Tube》東京 youtube space 的展覽:「藝術之夜 2015」。
表達主題為 youtube,像是許多來自螢幕中的 youtube 角色。

《the Hole Through a Tube》 This work is for an exhibition at youtube space tokyo "Art night 2015". Expressed the theme of "youtube", like various characters are coming out of screen like "youtube".

梁海傑 Keat Leong
www.keatleong.net

梁海傑的人生用在探討藝術、設計與動態圖像的數位
創作過程。在得到電影與動畫學位後，開始了動態設
計的創作職業生涯，之後，他待在新加坡與台北的動
態設計工作室。

目前他在吉隆坡是獨立的創意總監,他還在摸索數位
藝術的新境界,試著從轉換螢幕上的像素到畫布,產
生實驗性的視覺效果。這些創作表達出感謝與反思,
如同展開一段心靈之旅。梁海傑的作品在當地展出,
作品也被《Asian Creatives Book》、《Advanced
Photoshop》、《Motion Graphics Served》收錄。

Keat Leong explores the process of digital crafting
in art, design and motion. After graduating with
a degree in Film and Animation, his career began
with creating motion designs that mesh beautiful
aesthetics and fluid animations. Since then he has
worked with motion design studios in Kuala Lumpur,
Singapore and Taipei.

Currently, he is based in Kuala Lumpur as an
independent creative director. He also explores the
realm of digital fine art, translating experimental
visuals from on-screen pixels to the canvas. These
visuals are expressions of gratitude and reflections
to being on a yogic journey. Keat's art was exhibited
locally and published in Asian Creatives Book,
Advanced Photoshop UK and Motion Graphics
Served.

⌂ *Kuala Lumpur, Malaysia*
✉ *hkeat7@gmail.com*

《Free III (Free Series)》 該系列是個人自由與和平的探尋。這反映了獨立的
嚮往以及享無憂無懼在廣到世界翱翔的渴望。同時也象徵希望──這一個世
界,總有和平與自由。

《Free III (Free Series)》 This series is about the search for personal freedom
and peace. It reflects the longing for independence and the desire to fly
through the vast world freely without fear or worry. It also symbolises hope –
that when the world lives as one, there is always peace and freedom.

《Free IV（Free Series）》 該系列是個人自由與和平的探尋。這反映了獨立的嚮往以及享無憂無懼在廣到世界翱翔的渴望。同時也象徵希望——這一個世界，總有和平與自由。

《Free IV（Free Series）》 This series is about the search for personal freedom and peace. It reflects the longing for independence and the desire to fly through the vast world freely without fear or worry. It also symbolises hope – that when the world lives as one, there is always peace and freedom.

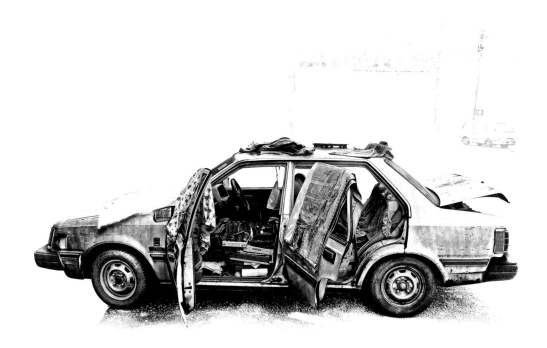

1.《Ipoh Memory Lane 1（Car Series）》 2.《Ipoh Memory Lane 2（Car Series）》隨著時間變化的金屬是非常美麗且劇烈的，如同車子對人的意義。對有些人來說，它不只是交通工具，是他們的生活型態、他們的家、他們的家庭、他們的生活。這個系列將車子擬化為人，每道痕跡是一種美麗，並反映了車主與他們的生活。

1.《Ipoh Memory Lane 1（Car Series）》 2.《Ipoh Memory Lane 2（Car Series）》There's something very beautiful and poignant about the way metal changes with time, as well as what a car means to someone. For some, it is more than a mode of transportation – it is their livelihood, their home, their family, and their life. This series documents the car as a character, displaying its every flaw as an item of beauty, and tells a story about the owner and their life.

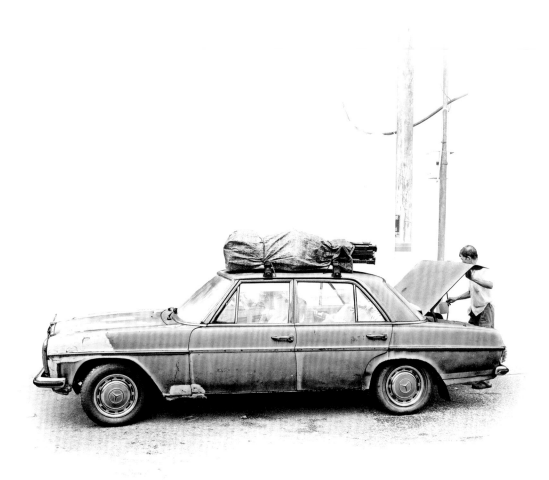

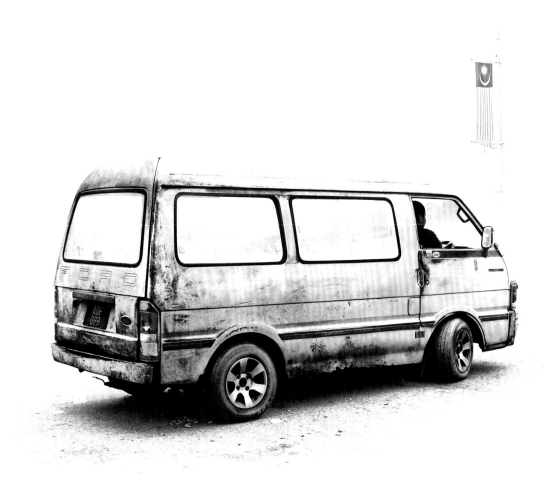

1 | 2

1.《Ipoh Memory Lane 3（Car Series）》 2.《Ipoh Memory Lane 4（Car Series）》隨著時間變化的金屬是非常美麗且劇烈的，如同車子對人的意義。對有些人來說，它不只是交通工具，是他們的生活型態、他們的家、他們的家庭、他們的生活。這個系列將車子擬化為人，每道痕跡是一種美麗，並反映了車主與他們的生活。

1.《Ipoh Memory Lane 3（Car Series）》 2.《Ipoh Memory Lane 4（Car Series）》 There's something very beautiful and poignant about the way metal changes with time, as well as what a car means to someone. For some, it is more than a mode of transportation – it is their livelihood, their home, their family, and their life. This series documents the car as a character, displaying its every flaw as an item of beauty, and tells a story about the owner and their life.

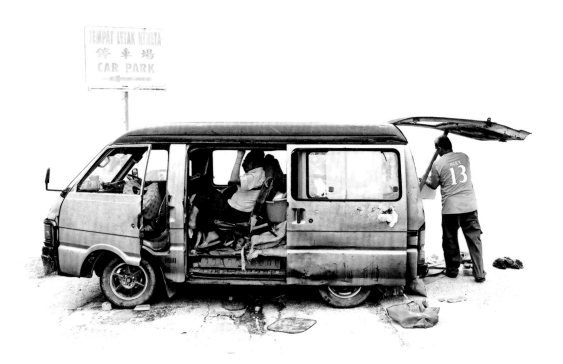

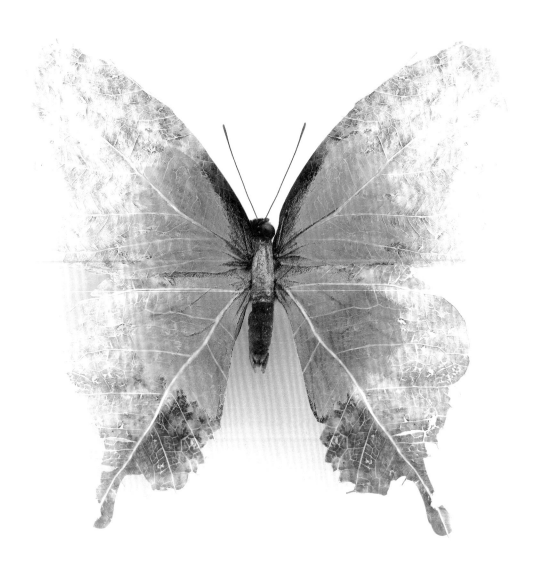

1.《Union Series 5/10》 2.《Union Series 5/10》受到花園中的枯葉所啟發，並驚嘆於自然細緻的美麗。自然，不論萌發或凋零——是永恆的美麗。蝴蝶是美麗的象徵，也代表每個人都可以蛻變成美麗的化身。

1.《Union Series 5/10》 2.《Union Series 5/10》 Inspired by a dried leaf in the garden, this is an appreciation of nature's intricate beauty. Nature - whether alive or withering - is eternally beautiful. The butterfly is a symbol of beauty and a subtle testament that everyone can evolve to their most beautiful being and be one with life.

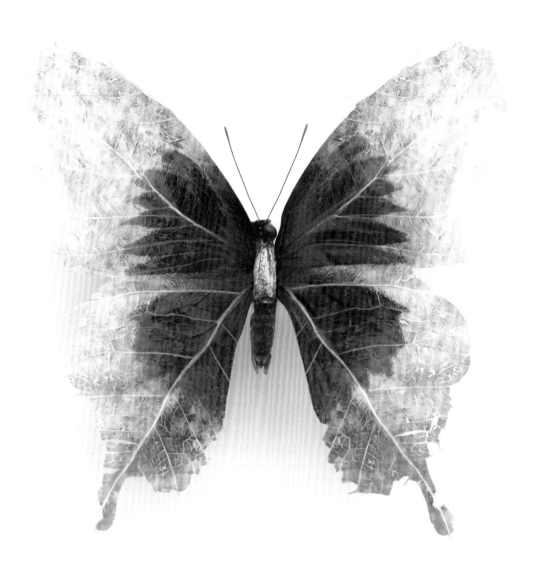

Alex Andreev
alexandreev.com

Alex Andreev（1972年）是俄國藝術家，目前居住在聖彼得堡，也在那裏工作。最近一次的專案為動畫「Koo! Kin-Dza-Dza」（資深概念藝術家），此亦為2013年亞太電影獎的得獎作品（最佳動畫）。

最近的展覽：
2014年波蘭華沙Kino Iluzion個人展「解離的真實」
2015年德國德勒斯登Ausländerrat Dresden e.V. 個人展「解離的真實」
2015年俄國聖彼得堡Erata當代藝術中心
「Metronomicon」

Alex Andreev (b.1972) is a Russian artist, lives and works in Saint-Petersburg. He's last project is an animated film "Koo! Kin-Dza-Dza" (senior concept artist), the winner of the Asia Pacific Screen Awards 2013 (best animated film).

Last exibitions:
2014 "A Separate Reality", Personal Exhibition, Kino Iluzion, Warsaw, Poland
2015 "A Separate Reality", Personal Exhibition, Ausländerrat Dresden e.V., Drezden, Germany
2015 "Metronomicon", Erarta Contemporary Art Center, St. Petersburg, Russia"

⌂ *prospect Toreza, 36/2, app.25, Saint-Petersburg, Russian Federation, 194021*
✉ *andreevbox@gmail.com*

個人作品，受夢境啟發。
Personal work, inspired by dream.

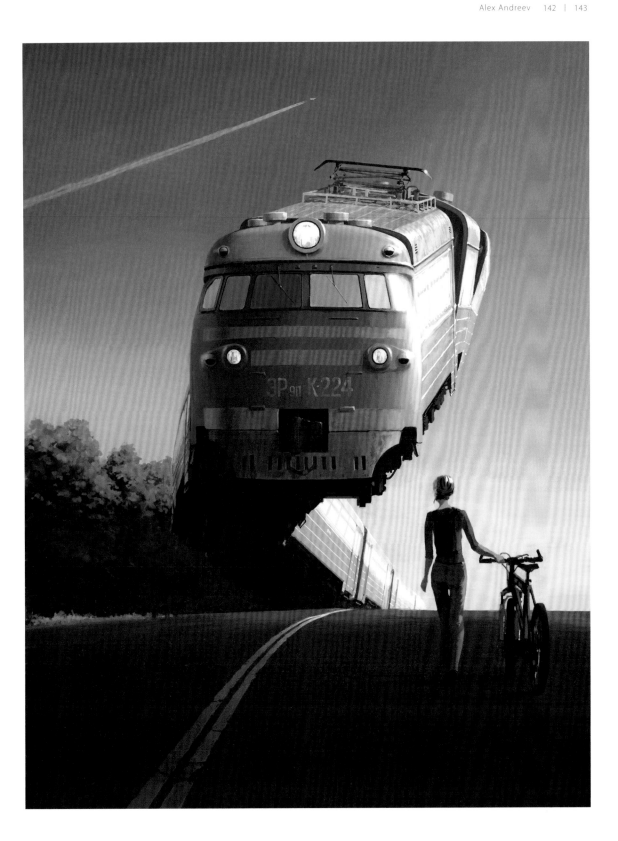

SAKIROO

sakiroo.com
behance.net/sakiroo

Sakiroo（韓文：사키루）出生於韓國富川市，本名 Sang-Hyun Choi（Hangul：최상현; hanja：崔相賢）。為南韓插畫家與角色設計師。他作品的主題多樣，包括運動人物的漫畫。曾參與多項展覽和專案（見下文），地點遍及韓國、法國、英格蘭、阿拉伯聯合大公國、中國、新加坡、美國、墨西哥、哥倫比亞和委內瑞拉等地。目前居住在首爾外的富川市，也在那裏工作。

Sakiroo (Korean: 사키루) is a South Korean illustrator and character designer, born Sang-Hyun Choi (Hangul: 최상현; hanja: 崔相賢), in Bucheon, South Korea. The subjects for his work are varied and include caricatures of sports figures. He has been involved in exhibits and projects (see below), including those in South Korea, France, England, United Arab Emirates, China, Singapore, United States, Mexico, Colombia, and Venezuela. He lives and works in Bucheon, just outside Seoul.

⌂ *205-401 Samik APT, Goean-dong, Sosa-gu, Bucheon-si,*
Gyeonggi-do, Korea
✉ *sakiroo@nate.com*

《Soccer Players》 我是個超級足球迷，因此不能錯過這場世界盃。世界盃是其中一個賽事。這幅作品展現出不同隊伍的球員的合照。

《Soccer Players》 I'm a BIG fan to football. so I can't be overlook to this world cup. WORLD CUP is one. This version shows group photo with their belong club.

1 | 2

1.《Bruce Lee》我從不同角度詮釋李小龍。 2.《DEATH LIST》根據東西方古代故事所做。

1.《Bruce Lee》I interpreted Bruce Lee via various side. 2.《DEATH LIST》It based on ancient story between East and West.

1 | 2

1.《Ducati in 90s》Ducati 是知名摩托車品牌。我90年代在韓國嚐試。
2.《Hamburger》如同速食漢堡一般出版的書籍。

1.《Ducati in 90s》Ducati is brand which known motocycle. I tried in the Korea 90s. 2.《Hamburger》Hamburger as fast food for book publishing.

1 | 2

1.《Virtual Reality 1》 這個故事描繪的是盲目約會*。我猜許多人在不久將來會用虛擬實境*（VR, virtual reality）以及擴增實境*（AR, Augmented Reality）約會。他們可以藉由虛擬實境了解對方的想法，並用擴增實境溝通。
2.《Virtual Reality 2》 故事描繪床上的一對情侶。我猜當情侶在床上時，會利用虛擬實境感受高潮，像開胃菜。

1.《Virtual Reality 1》 This story of illustration is blind date. I guess many people have use a VR and AR in early future. They can see a their ideal type via VR. and conversation with AR. 2.《Virtual Reality 2》 This story of illustration is Couple on the bed. I guess that when couple on the bed, they can feeling orgasm via VR. like an appetite.

* 盲目約會：指雙方男女在雙方不熟識的情況下約會。
* 虛擬實境：利用電腦模擬產生一個三度空間的虛擬世界，提供使用者身歷其境的感官環境。
* 擴增實境：一種把虛擬化技術加到使用者感官知覺上再來觀察世界的方式。

《ICHABOD2》文明中充滿恐懼，但我們的大衛會拯救我們。

《ICHABOD2》In Civilizations Horrors Abound But Our David will save us.

双人徐Shuang Ren Hsu
shuangrenhsu22.tumblr.com

1991年生於台灣
現為視覺設計師也是插畫家
擅於多元風格之插畫，但更愛時尚肖像畫
曾入選第五屆亞洲青年創作集錄
與曾為台灣金鐘獎繪製表演動畫

Born in 1991 in Taiwan. Currently works as a visual
designer and an illustrator. Specialized in multiple
illustration styles. Deeply in love with the fashion
portrait illustration. Featured on Apportfolio Asia vol.5
and produced performing animation for Golden Bell
Awards in Taiwan.

⌂ 新北市土城區學府路一段23巷25弄56號
No.56, Aly. 25, Ln. 23, Sec. 1, Xuefu Rd., Tucheng Dist., New
Taipei City 236, Taiwan
✉ shuangrenhsu22@gmail.com

《Unisex》無論是他或是她，就只關於「你」。
《Unisex》It doesn't matter he or she It's just about YOU.

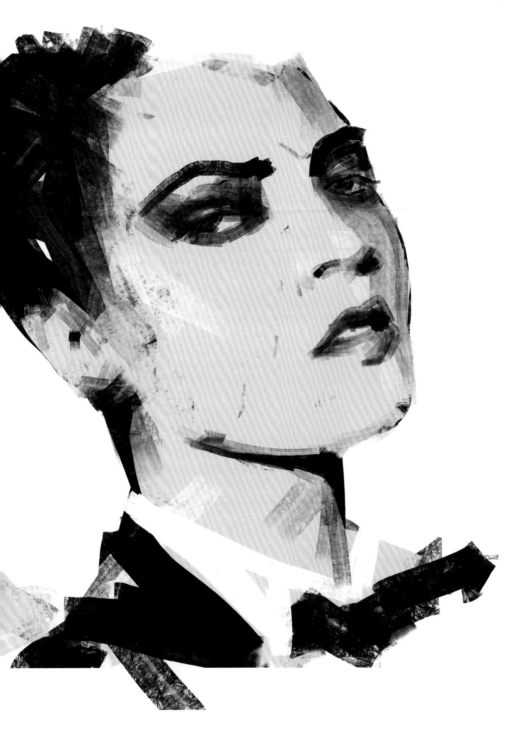

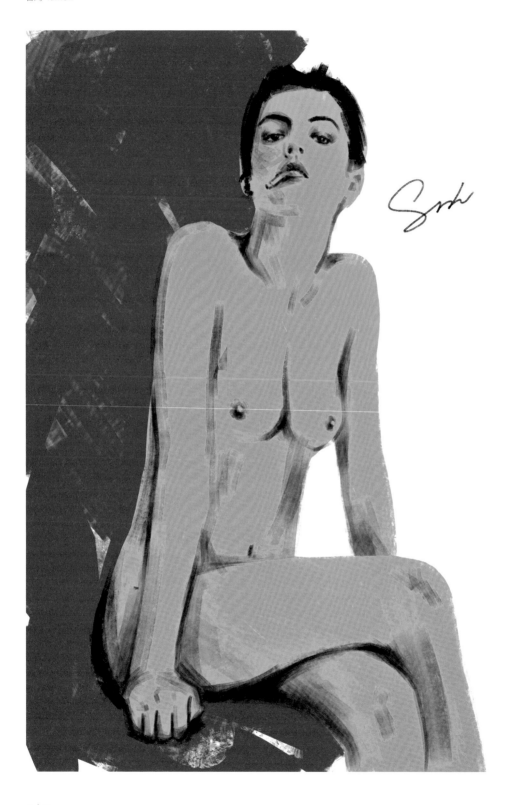

1 | 2

1.《Afterward》這個世界摧毀了每個人，之後，許多人在毀壞的地方重生。
2.《Erlend Øye》以 Erlend Øye 在台灣的巡迴演唱的照片所做，運用對比色的硬筆刷繪製。

1.《Afterward》The world breaks everyone, and afterward, many are stronger at the broken places. 2.《Erlend Øye》Made for the concert image of Erlend Øye Legao tour in Taiwan, using hard brush with contrast color.

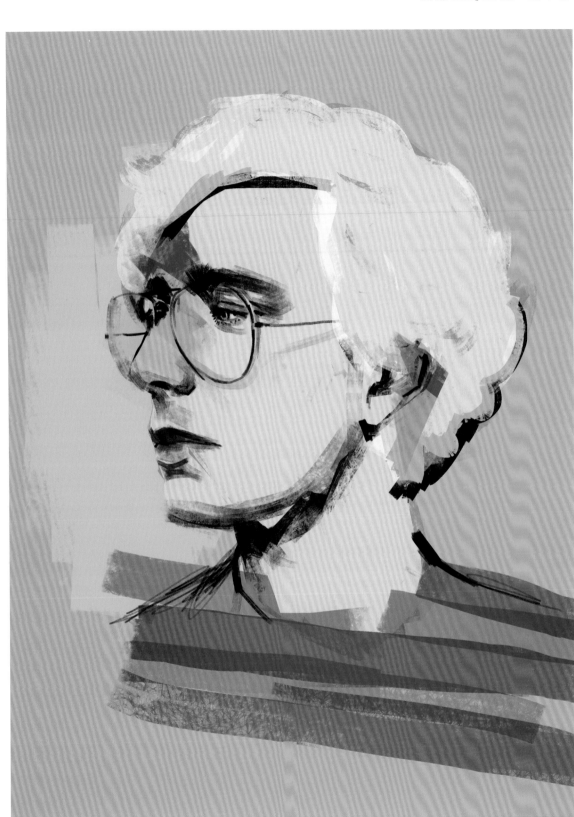

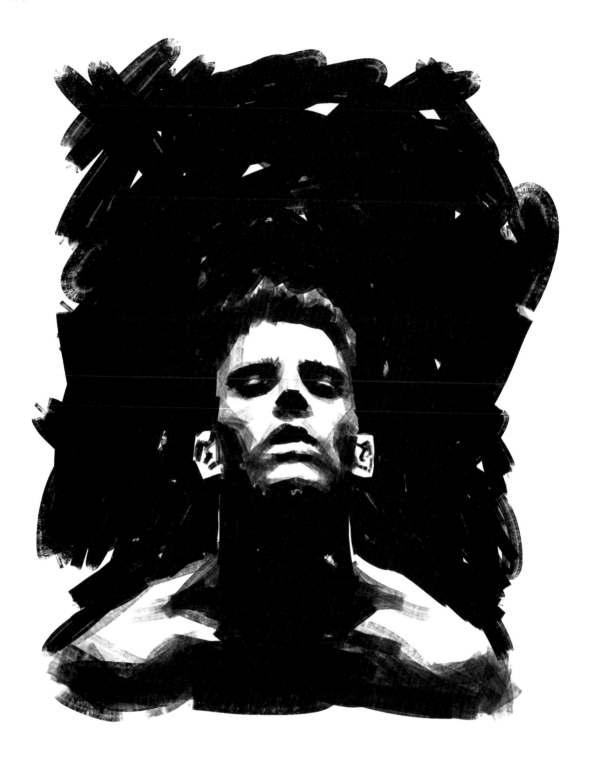

1 | 2

1.《Dark》漆黑無月的夜晚。　2.《Cover》像你過去一樣保護我。

1.《Dark》That was a dark, moonless night.　2.《Cover》Cover me like you used to.

1 │ 2 │ 3

1.《Baseball boy》無。 2.《Tough》向眉毛一樣硬。 3.《Glance》無。

1.《Baseball boy》 None. 2.《Tough》 Be tough like the eyebrow.
3.《Glance》None.

次叔 Lin Zheng Rong
www.facebook.com/linx690505

曾經歷遊戲、動畫製作，目前為自主動畫創作人。

In the past worked in animation & game company,
I'm currently an independent animator.

⌂ *23568 新北市中和區忠孝街55巷1-2號2樓*
2F., No.1-2, Ln. 55, Zhongxiao St., Zhonghe Dist., New
Taipei City 235, Taiwan (R.O.C.)
☑ *linx690505@hotmail.com*

《相遇》 猴：你這小傢伙老跟著俺，俺要回家了呀／犬：嗨～嗨～嗨～／猴：俺很窮跟俺一塊吃不到好料喔！／犬：嗨～嗨～嗨～／猴：哎好拉俺一人也不差你這飯碗，走～／兩人彼此找到伴。

《Encounter》 Monkey: A little guy, I'm go home, Why do you always follow me? / Doggie: Hey ~ Hey ~ Hey ~（Still follows）/ Monkey: I am very poor, I can't let you full! / Doggie: Hey ~ Hey ~ Hey ~（Still follows）/ Monkey: Alright, because I have been always alone, I think it doesn't matter to save some for you and have you as a company. Let's go! / They become each other's company.

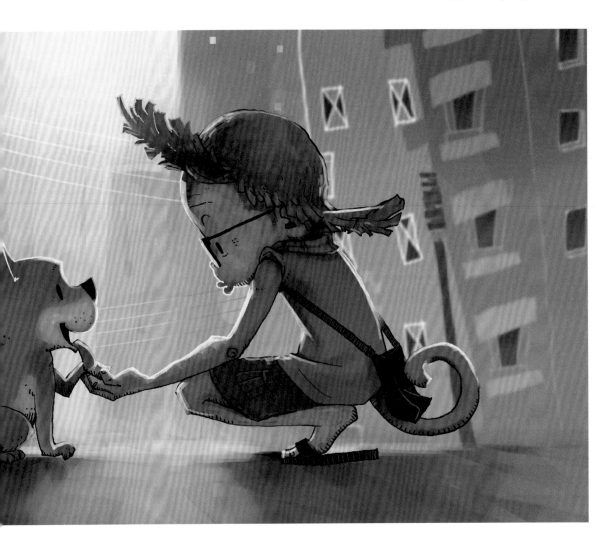

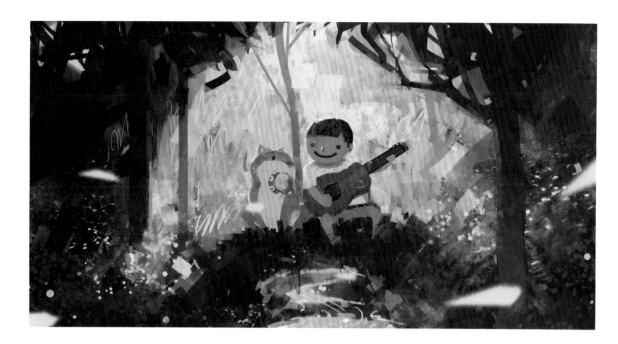

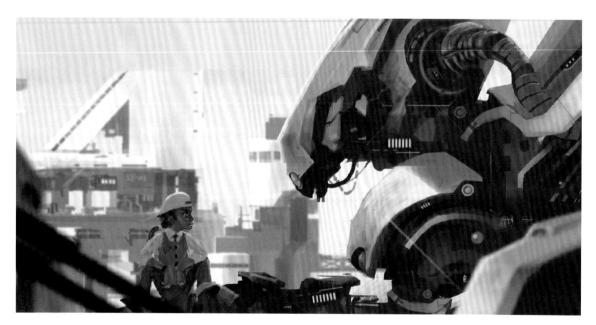

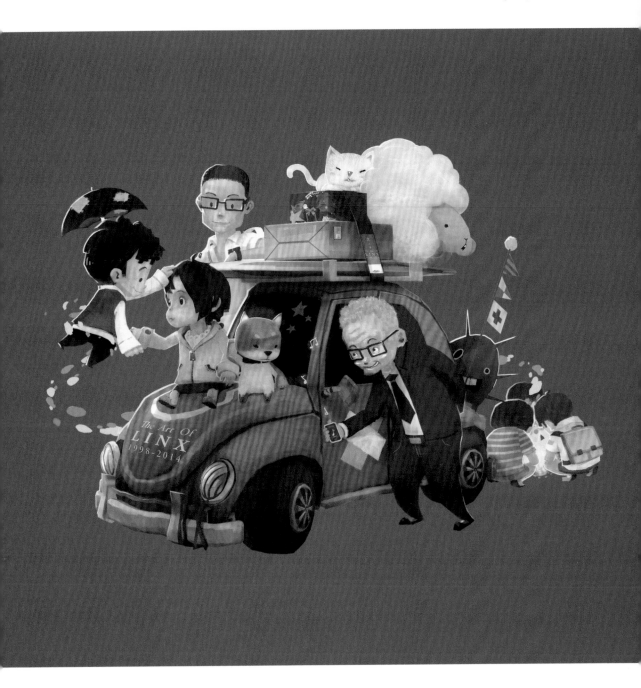

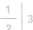 3

1.《綠林螢光》陽光照映下，柴犬搖鈴替吉他聲伴奏。我們聽著輕快的曲子與自然的聲音、觀賞周圍的螢火蟲搭配著旋律閃爍。 2.《父子》 渺小的男孩創造出大型的機械人，如同父子般的感情彼此互相凝視。 3.《聚》 過去所有創造出來的角色大集結。

1.《Forests & Fireflies》 The Shiba dog rings the bell to accompany the guitar under the sunshine. We listen to the light music and the nature sounds, and watching the fireflies twinkling with the melody. 2.《Father and son》 The little boy created a giant robot, and the way they look at each other is like father and son. 3.《Gathering》 The get together of all the characters created.

旅人奇遇

SHIBAPOWER ANIMATION presents
boogie.freeserver.me/the_traveler/index.html
Music by WinsoundStudio. Designed by Aliang & LINX .
© All Right Reserve.

1 | 2

1.《旅人奇遇》旅人奇遇的故事雛型是在金門當兵休假時，獨自一人遊走荒涼但獨特的老村落，忽然想到的。幾年後，同事看了這篇初稿，提議咱來作成動畫應該不錯！於是，旅人奇遇就此誕生。　2.《週五夜》週五的夜晚。

1.《the traveler》The story prototype from I'm a soldier on leave in Kinmen. I thought the story, when I walked alone in a desolate village. A few year later, when my friend saw the story. He say: Maybe, it should be pretty good to an animation.　2.《Friday Nights》Every Friday nights, I fill them with drawings and animation, and getting used to it.

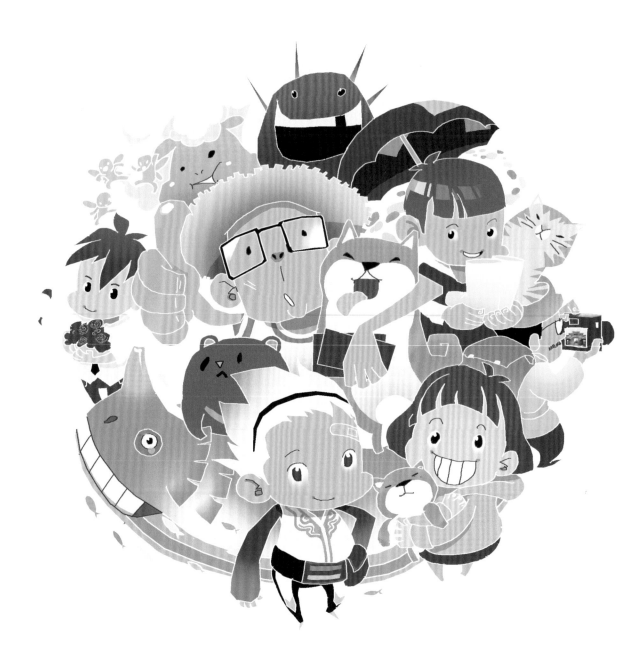

1.《孩子們》營造熱鬧氣氛來著的羊年賀圖，過去所有創造出來的角色大集結。
2.《逝去的愛情》喜歡的女孩身旁已有好男生時，還是默默地離去祝福他倆吧！

1.《Children》 The picture of the sheep year that creates a joyful environment, is the get together of all the characters created. 2.《Lost love》 When the girl you loved already has another guy, just silently let her go and wish her good luck.

披薩先生 Mr.PIZZA!
www.behance.net/pizzart

2001 銘傳大學商業設計畢業

2003 投身專職插畫，耕耘幼教、國中小學兒童與
　　　少年插畫十餘年至今

2006 三采創意市集102與插畫市集301封面與專訪

2007 黑秀／面向插畫展邀請
　　　北京／台灣新銳主題插畫展

2012 三采插畫市集台北書展插畫交流展

2014 台灣藝術家博覽會

2014 FLiPER 11月封面與專訪

2015 FLiPER RED Exhibition 插畫聯展

2015 Mighty Jaxx's Maitreya Custom Show

2015 奇遇X歧寓 插畫雙人展

Ming Chuan University Business Design Graduation
2001, full-time illustrator. I draw nothing but love ,faith
and passion.

⌂ 台灣新北市三峽區二鬮路136巷24弄77號11樓
*11F., No.77, Aly. 24, Ln. 136, Erjiu Rd., Sanxia Dist., New
Taipei City 237, Taiwan (R.O.C.)*
✉ pizzart@gmail.com

《下廚樂》根瓜葉莖好新鮮／蔥段薑末蒜切片／燉炒滷烤煨炸煎／糖鹽
醬醋巧拿捏／七手八腳忙中樂／廚房有我香滿間
《Fun cooking》Cooking robot help me prepare dinner, cooking has
become very easy.

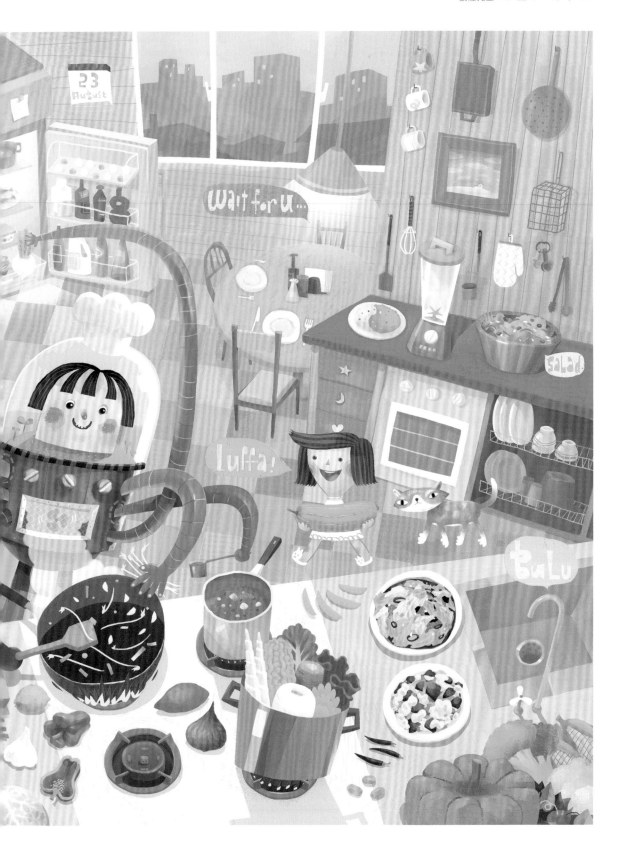

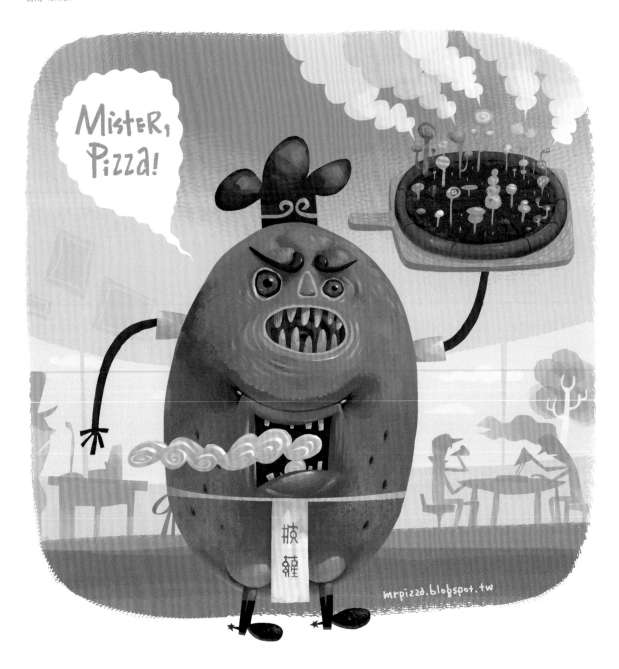

1 | 2

1.《先生，披薩來了！》我的筆名來自於披薩外送員最常說的一句話：「先生，披薩來了！」"Mister, pizza!"念起來和"Mr. PIZZA!"一樣，中英互換之下就成了"披薩先生"。起因除了大學時期曾做過披薩外送，最早可追溯到小時候玩過的一款電腦遊戲，裡頭有個小小角色敲門大喊"PIZZA!"，那時真覺得PIZZA!是個充滿力量的字眼呢！（笑）2.《休息一下》FLIPER雜誌封面，將舒壓良方—閱讀、購物、玩具、植栽、戀愛、玩耍和LOGO結合。對我來說最棒的舒壓就是面對空曠，尤其是一望無際的大片草原。

1.《Mister, pizza!》 That is why I am "Mr.PIZZA!". 2.《Time for a break》 FLIPER magazine cover,how to relax? / F：reading / L：shopping / I：toy / P：plant / E：fall in love / R：play

1｜2

1.《聖誕老公公的大麻煩》聖誕老公公摔破了麋鹿的頭，禮物撒了一地，雪人們從麋鹿頭裡逃了出來！他們非常調皮，只有在小孩面前才會靜止不動，但荒郊野外沒有小孩，雪人們肯定會大鬧一場！離下個村子還很遠，聖誕老公公的麻煩可大了⋯⋯。　2.《龍年遊樂園》配合康是美龍年行銷，龍年主題樂園裡有雲霄飛龍、大龍神、摩天龍輪、旋轉木龍等等和各式各樣含有龍與新年意象的遊樂設施。繽紛色彩中帶入大量企業代表色橘色，以加強消費者視覺印象。

1.《Santa's big trouble》Santa smashed the deer's head, gift scattered over the ground, and snow men escaped!　2.《The year of dragon wonderland》For Cosmed marketing,so I use a lot of orange.

1 | 2 | 3

1.《天作之合》博學多聞的新郎從書本裡蹦出來，腳底下踩的是一場場的人生馬拉松，手裡負責的是新娘下半輩子的三餐。美麗大方的新娘在丘比特和兩隻愛貓的護送之下，抱著兩人未來的夢想，在教堂前，戴上代表永恆的鑽石戒指。
2.《世界青光眼日快樂》我罹患青光眼後才知道有世界青光眼日(週)這樣的日子，既然有這樣的節日，當然要快樂一下，以樂觀的態度和正確的護眼觀念面對它。青光眼最明顯的症狀便是夜晚在燈光周圍會見到彩虹般的光暈，以及眼壓飆高時的眼痛腦袋痛。 3.《台灣人的零組件》將台灣人的飲食習慣和身體做連結，豬腳補膝蓋、木瓜牛奶有助乳房發育、充滿全身的台灣啤酒，更有防腐劑、起雲劑、塑化劑、地溝油以及399吃到飽的火鍋換來的永遠洗腎，以諷刺的方式反思飲食健康。

1.《Together forever》Life is a marathon, and i meet you, we will run together. 2.《Happy world glaucoma day》With glaucoma, you will see rainbow at night and headache everyday. 3.《Parts of Taiwanese》Eating habit of Taiwanese. We love food ,but we love preservatives, plasticizer and cloudifier more.

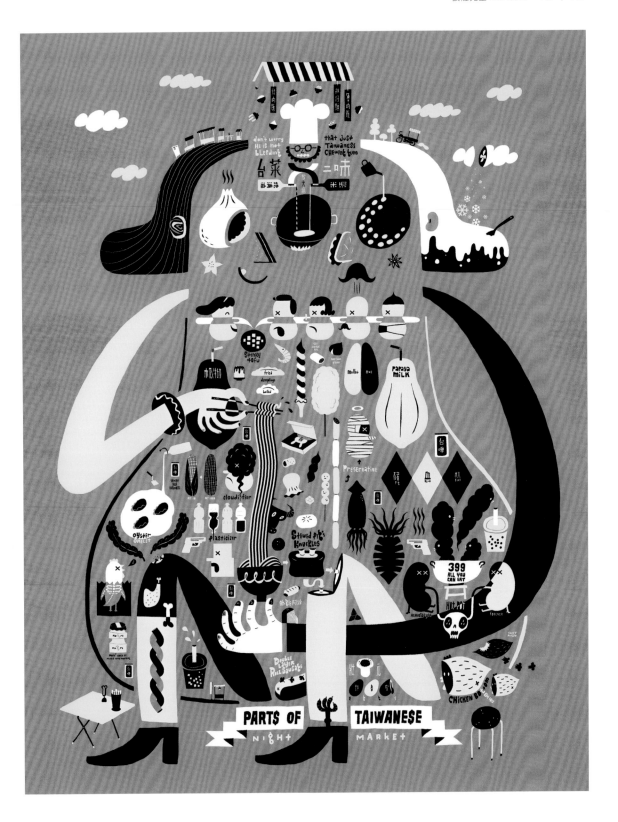

林廉恩 Lian-An

www.behance.net/nonestates

出生和生長於台灣。銘傳商設畢業後在偶動畫公司擔任角色與美術設計一年多離開後才開始畫圖，最初接案不穩、酬勞不高時，也有在美妝店打工支撐生活。擅長使用壓克力及水性蠟筆進行創作，雖然也會使用電腦繪圖，但因為喜歡顏料帶來的質感和溫度，所以主要還是以手繪為創作方式。創作內容多以當下的感受或是生活經驗為主題。喜歡兒童插畫、貓狗、古老的東西、下雨天和驚悚小說。曾獲得2014美國3×3當代插畫獎及2015波隆那兒童插畫獎。

Born and raised in Taiwan. She graduated from Ming Chuan University and majoring in Commercial Design, and worked as a role and art designer for an year. After she resigned the work, she started her career in painting. At the beginning of time, without stable cases and income, she worked in cosmetic shop to maintain life. She's specialized in acrylic colors and watercolor crayons. She creates digital works sometimes, but prefers hand painting due to the texture and warmth of colors. The topic of her works is mainly from her feelings or life experience. She likes children's drawings, cats and dogs, old stuffs, raining days and horrified novels. She's Merit of 3×3 Proshow 2014 and an awarded winner of Bologna Children's Book Fair 2015.

⌂ *台灣新北市蘆洲區水湳街160號4樓*
4F., No.160, Shueinan St., Lujhou Dist., New Taipei City 247, Taiwan (R.O.C.)
✉ *xu06p714@gmail.com*

1.《會發光的蟲子01》 世界經過大爆炸後，所有的動植物生長迅速。 2.《會發光的蟲子04》 莫瑞帶著發光的蟲子出發尋找同伴，半路上因為疲累稍做休息，但是有人卻發現了他們。

1.《The radiant bug 01》 The world after bomb, animals are growing constantly. 2.《The radiant bug 04》 Murray and his little friend leave to look for friends, but someone discover them.

1 | 2

1.《小行星的野餐聚會》 小行星們要等兩千三百二十七億零五光年才能因擦身而過見上一面，所以他們精心的準備了餐點慶祝！ 2.《星星安樂工廠02》 在銀河的盡頭，有一個秘密的星星安樂工廠。星星工人們正為了明天的開幕儀式加緊趕工。

1.《The picnic of plant》 The plants has waited 23270000005 light years to get together. So they prepare picnic to celebrate! 2.《Peace Factory of stars 02》 There has a "Peace Factory of stars" in the end of galaxy. The workers speed up the work fortomorrow's opening ceremony.

1 | 2

1.《愛情的第一個階段》 熱戀。愛情初萌芽時，你就像一隻可愛的小狗，就連你嘴裡的小蟲我也當成美味佳餚。 2.《愛情的第三個階段》 冷戰。經過熱戀然後爭吵，我們進入冷戰階段，你像隻灰心的公雞，嘴裡不斷碎念。

1.《Love process 01》 fire love. When love is beginning to sprout, you're like a cute puppy. Even the bug in your mouth, I regard a delicacies. 2.《Love process 03》 The third stage of love: cold war. We entered the stage of the Cold War. You like a discouraged roosters.

Fill with something warm to the city.

1 | 2

1.《傑克森的白日夢》 傑克森剛下班，在回家的車上睡著了。半夢半醒之間他
看到了一個奇異的世界。 2.《Fill with something warm to the city》 為這城
市種下一些溫暖，每顆小樹都成為城市的心臟，靜靜的跳動著。

1.《The daydreams of Jackson》 Jackson just got o work. He fall a slept
on the bus. Between awake and dream, he saw a strangeworld. 2.《Fill
with something warm to the city》 Fill with something warm to the city.
Every single tree has become the heart of the city, beating quietly.

欣蒂小姐 Miss Cyndi

misscyndi.com
www.facebook.com/MissCyndiLin
www.instagram.com/misscyndiiii/

熱愛插畫的女子因緣際會掉進插畫圈，創作色調輕柔，擅長描繪動物與女性，作品散見雜誌、品牌廣告與書籍封面設計，並於 2015 年出版第一本關於愛情與味道之圖文書，現與三隻非人類同事，組織在家工作室。

Miss Cyndi is an illustrator and artist who worked as a freelancer for several years based in Taiwan. She loves literature and art. She also likes all types of animals and has three dogs.

✉ *cyndi@misscyndi.com*

《古今共存》 象徵知識的老樹下感受文字薰陶，書是知識與歷史傳遞的最佳媒介，書是文化與藝術保留的最佳寶庫，隨著歷史與知識經年累月地堆積，盛開一本又一本珍貴飽滿的果實。

《Time Travel》 Tree of wisdom was cultivating by words. A book is the best media for knowledge and history. A book is the best treasure house to preserve culture and art. With accumulation of history and knowledge by years, Precious and fruitful fruit is born.

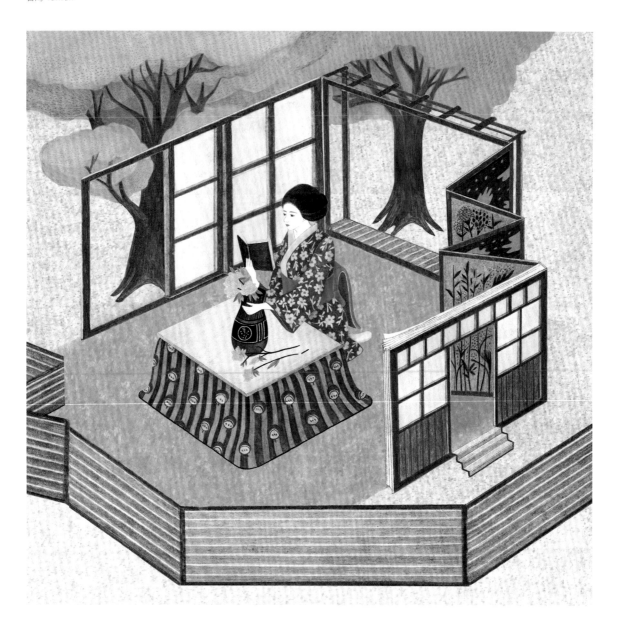

1 | 2

1.《文化珍存》書是文化與藝術保留的最佳寶庫。　2.《傳承知識》書是知識與歷史傳遞的最佳媒介。

1.《Preserving Culture》A book is the best treasure house to preserve culture and art.　2.《Knowledge Inheritance》A book is the best media for knowledge and history.

1 | 2 / 3

1.《象徵知識的老樹》歷史與知識經年累月地堆積／形成一本又一本珍貴的果實 2.《對母親的記憶》物品能承載情感／味道會勾起回憶／而照片留存時光 3.《對父親的記憶》文字紀錄當時情緒／而手寫能保留溫度

1.《The Knowledge Tree》With accumulation of history and knowledge by years. Precious and fruitful fruit is born. 2.《Childhood Memory》An Object delivers emotion. A taste evokes memories. But a photo preserves times. 3.《Childhood Memory》Words records the feeling at that time. And handwriting can keep warm.

陳可 Chen Aco

www.behance.net/acochen

自由插畫工作者，喜歡自詡為生活觀察者，認定生活靈感來自於家中飼養的柴犬。喜歡遨遊在自我繪畫創作的世界當中。近幾年在插畫創作當中加入自己對於社會現象觀察與發生在生活周遭的大小事，一方面記錄自己的生活，一方面創作自己最熱愛的插畫。

曾任雲科大視覺所「釀-碩班聯展」總召集人，並參與四分之四大於一聯合展覽策劃團隊。在2015年獲邀至「台灣香港新銳插畫交流展」擔任講者，並在2014年「AAD亞洲視覺藝術交流展設計講座」任主講人。過去曾於2013年獲得台灣插畫師協會「2012台灣插畫戰隊召集賽優秀插畫獎-入選」。

Be a life-observer and love illustration forever. Reading picture books and drawing are my favorite since I was a little girl!. I would love to travel my world of painting. In recent years, I used to combine the current affairs with my illustration and record something I like everyday. And that is what I will do in the future until I am old. I love painting for no reasons.

⌂ *台南市北區臨安路二段195巷10號*
No.10, Ln. 195, Sec. 2, Lin'an Rd., North Dist., Tainan City 704, Taiwan (R.O.C.)
✉ *acoirene@gmail.com*

《我與我的柴犬底迪》我們一起吃早餐，一起享受每一刻。
《My Shiba inu Didi and me》 We have breakfast together, and we enjoy doing everything together.

1 ｜ 2

1.《你會怕嗎?》不要怕……我永遠都會陪伴你。　2.《咖啡時光》喜歡一個人的
咖啡時光,尤其世界都還在沉睡時。

1.《Are you afraid?》Don't be afraid dear... I'll be with you forever.　2.《Coffee time》 I like the coffee time with myself, especially when the world isn't wake up.

1.《秋天》秋天，一定要吃秋刀魚。 2.《歡樂鳳梨國》這裏的居民愛吃鳳梨，這裏的居民比任何王國的人都快樂，這裏是臺灣關廟！ 3.《你無聊嗎？》我知道你可能很無聊，但我現在只想躺在床上。

1.《Autumn》We must eat sanma in autumn. 2.《Happy Pineapple Kingdom》 People here likes to eat pineapple, people here is happier than other kingdom's people, Here is GuanMiao in Taiwan! 3.《Are you bored?》 I know you might feel bored, but I just want to lay in my bed.

1 | 2

1.《河畔》夜晚來到河邊。享受一個人在沿著河畔走，享受一個人的時光。
2.《早安你好！》每一天早晨，我們都在等著最燦爛的微笑。

1.《Riverside》Down by the riverside at night. I enjoy to walk to the borders on my own and enjoy the time with myself.　2.《Hey!Good morning!》We like to meet the beautiest smile every morning.

陳威元 Chen Wei-Yuan

http://chen-wei-yuan.tumblr.com/

1993年出生，目前就讀國立臺北藝術大學動畫學系，動畫作品有《扭蛋叩嘍叩嘍》（2014）、《SWIM YOUR WAY》（2014）、台灣動畫杯片頭（2014）、《怪獸們》（2015）等等。2014年獨立出版個人插畫集《怪獸們》，並與系上同學出版《霧中之蛹》漫畫合集，以及參與獨立刊物TAIWAN COMIX 8 創作等。

Born in Taiwan Taipei. Currently he is studying animation at Taipei National University of the Arts. Besides animation, he also creates illustrations, comics, and scale models.
Animation works include "Swim Your Way," "Gashapon Kou-lou-kou-lou," and "Monsters." Published works include personal illustrated collection "Monsters," collaborated works "Pupa in fog" by 7 animation students, and "Pupa in fog2" by 9 others in Taipei National University of the Arts.

✉ *alexwaaa@gmail.com*

《上山採藥去》香菇博士乘著心愛的鳥兒上山採藥草。
《Going up the hill and collecting herbs》 Dr.mushrooms goes up the hill to collect herbs by riding his beloved bird.

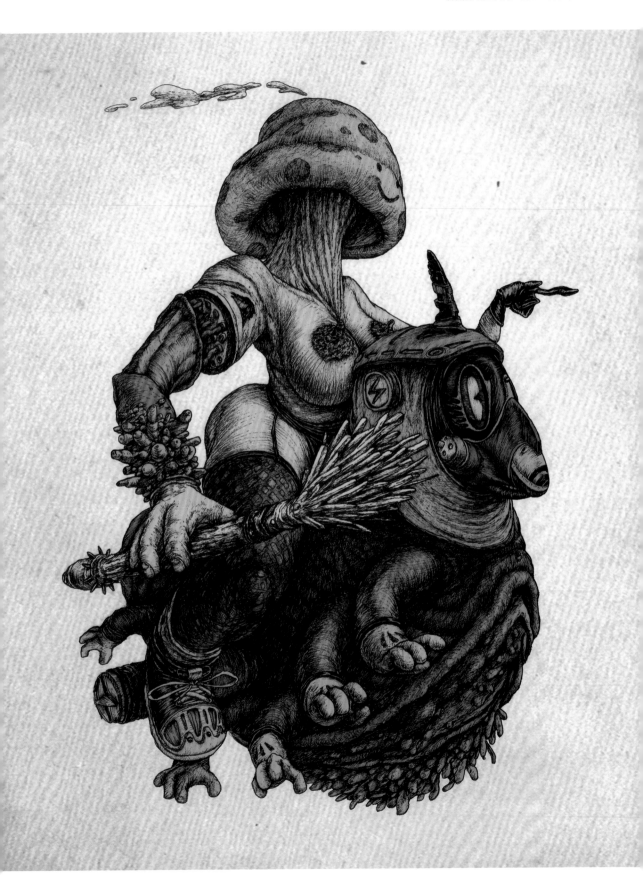

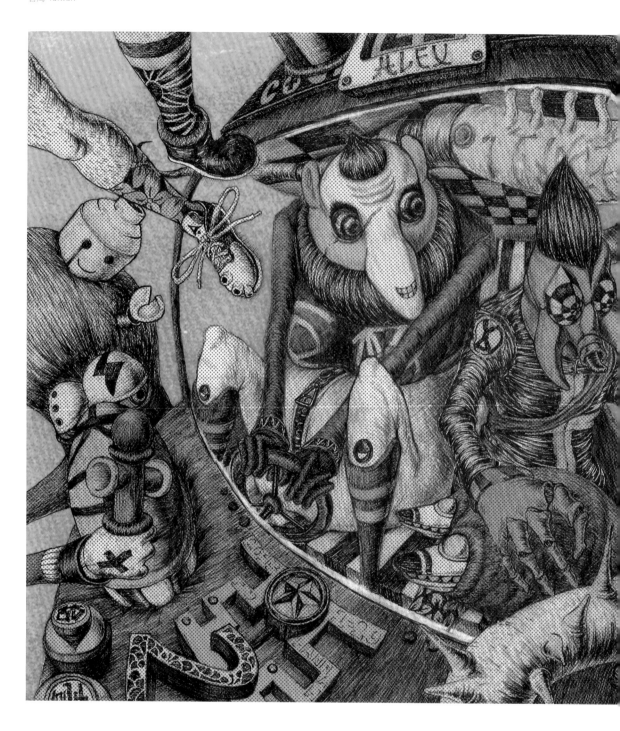

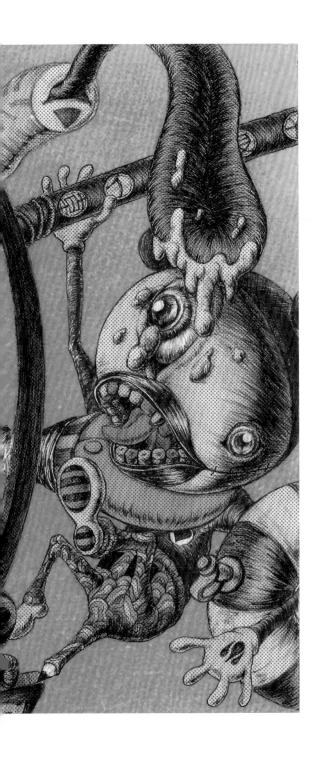

《出遊》弱者為群體帶來和諧。

《An excursion》The weak bring the harmony to the group.

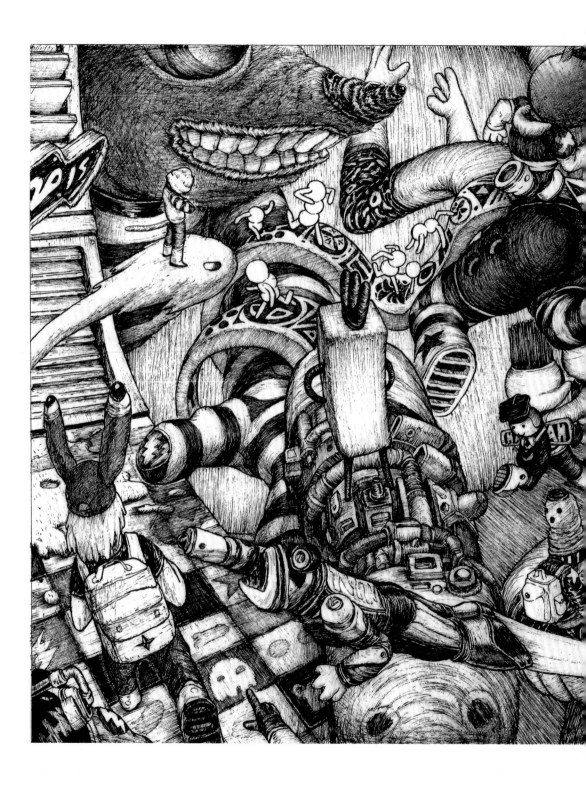

《房間裡的秩序》房間裡，每人各司
其職，形成井然有序的小世界。

《An orderly scene in the room》
Everyone takes their own role in
the bustling room.

1 | 2

1.《玩具與性》童年與成年的慾望交織。 2.《無害巨獸》可怕的巨獸其實很溫柔，小小的人類才是加害者。

1.《Toys and sex》Childhood intertwines with adult desires. 2.《A tremendous innocuous monster》A tremendous monster is gentle. Conversely, the little human is the offender.

1 | 2

1.《機械之後》當機械耗盡之後，得以野蠻解決問題。 2.《怪獸小學的日常》怪獸小學的日常。

1.《After civilization》When machinery runs out in the future, we'll have to solve problems in a barbaric way. 2.《A daily activity in MONSTER primary school》A daily activity in MONSTER primary school.

陳興仲 Chen Hsing-Chung
www.tumblr.com/blog/joechen115

陳興仲，台灣高雄人，從小生長於工業區旁。自小對
藝術美學備感興趣，大學往藝術及設計領域發展，熱
愛視覺藝術，喜歡藝術感強烈之創作作品。創作時喜
歡考慮觀眾與作品之間關係，且希望兩者產生互動；
常於作品中摻入許多隱藏符碼及視覺語彙，增加作品
表象之下更多層次的意義，讓作品能夠一再玩味。

Chen Hsing Chung , From Taiwan, Kaohsiung. In his
childhood, he lives beside the industrial zone, and he
was interest in aesthetics. When he was in college,
majored in art and design, especially love visual art or
the work which has art emotion. As he creates, always
try to think about the relation of viewer and the work.
Not only that, he also hope they have interaction.
He works insert a lot of oblique codes and visual
vocabularies to add more hidden meanings to let
work can ruminate over and over again.

⌂ 高雄市大寮區光華路132巷30號
No.30, Ln. 132, Guanghua Rd., Daliao Vil., Daliao Dist.,
Kaohsiung City 83157, Taiwan (R.O.C.)
✉ *joe36978115@gmail.com*

《大城入港》如果從海上看回高雄這個海灣與河流交接的港灣城市，會是什麼面
貌？承載於貨輪上的貨品轉變為高雄的城市建築，代表它的興盛是由往來的貨
輪運送出它的繁華，而工人是高雄港不可或缺的功臣，如同助這個城市一臂之
力，成就一個有生命的港灣。

《Big City Sails to the Harbor》 What appearance do you think about if you
see the harbor city of Kaohsiung bay connect to river? The goods which
are carried on the cargo ship all change to the Kaohsiung city's buildings. It
means Kaohsiung's prosperity is because cargo ship can transport flourishing
and for Kaohsiung harbor to say, workers are necessary people who help the
city achieve to life harbor.

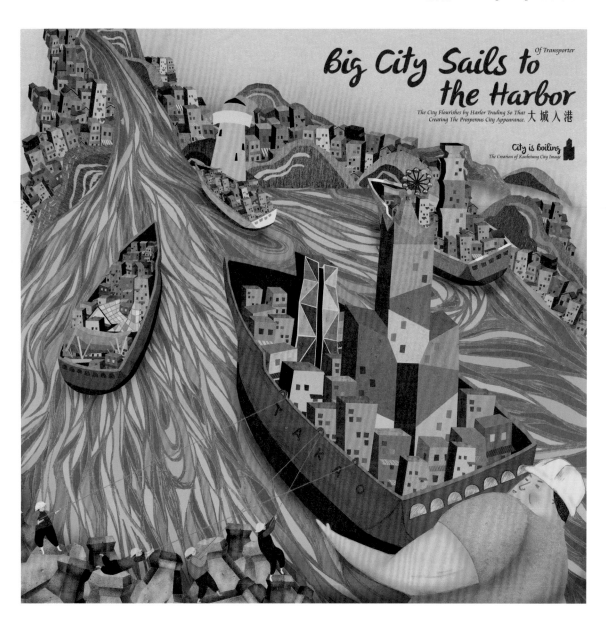

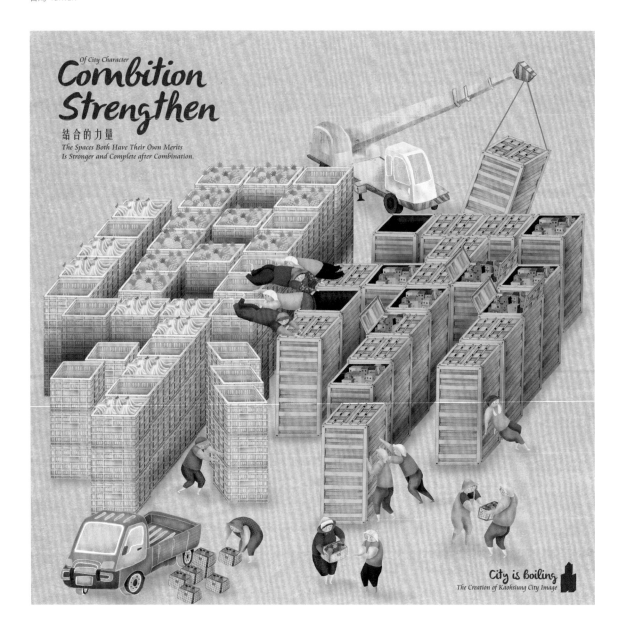

1 《結合的力量》縣市合併讓高雄更強大,將「县市」(讀音:都)字意義融入作品中,「縣」以農用塑膠籃象徵豐富的農業資源;「市」以貨櫃象徵貨輪往來繁榮的海港城市;其中的農人與工人皆努力拼湊出這個字完整的樣貌。 2 《棋盤上的城市》高雄從一到十的路名是高雄街道最大特色之一,下棋的工人及農民鳥瞰這個有趣的棋盤之城,而基底以貨櫃拼湊而成,代表這個城市的根本。

1. 《Combination Strength》 Kaohsiung city merge with surrounding country and expand in scale let Kaohsiung to be stronger so that I make the "capital" meaning into the work. I also use agriculture's plastic basket as "country" to symbolize for abundant agriculture and use container as "city" symbolize for cargo ship go back and forth to prosperous harbor city. The farmer and worker all try hard to put the complete appearance of the word together.

2. 《Chessboard City》 Kaohsiung's street names which are named from one to ten are the one of the most special things of Kaohsiung streets. Worker and farmer who play chess are looking down at this interesting chessboard city and the city was built by containers, it is standing for the container is root of the city.

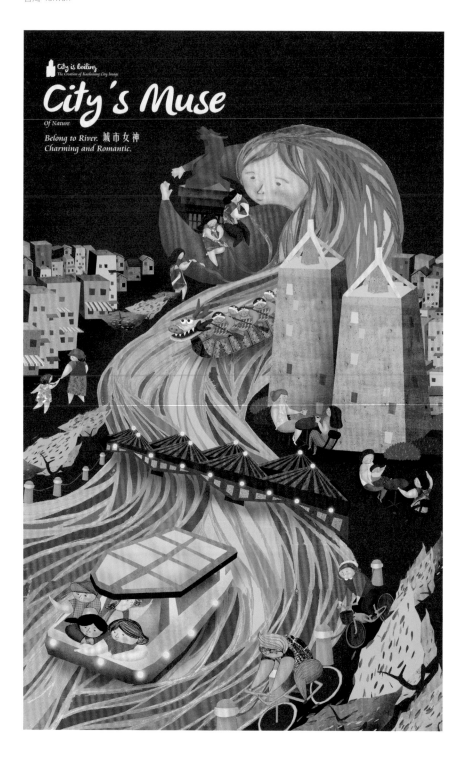

1|2

1.《城市女神》一個成功的大城市一定有一條屬於它的河流，而高雄的河非愛河莫屬。高雄的改變正在四處發生，從愛河一直貫穿高雄港，在這個城市的蛻變過程中，愛河從過去鳥無人煙的河岸，轉變為詩人口中的謬思女神、民眾心中的休憩河畔。 2.《城市硬漢》城市之所以讓人眷戀，是因為有讓然牽掛的人事物，又或

是某種稱做生活的「氣味」。高雄給人的除了炙熱的陽光之外，大概就是一種海味吧！高雄的海就如同一個血氣方剛壯年，有著剛硬的性格，騎著三輪車賣力的為生活打拚。

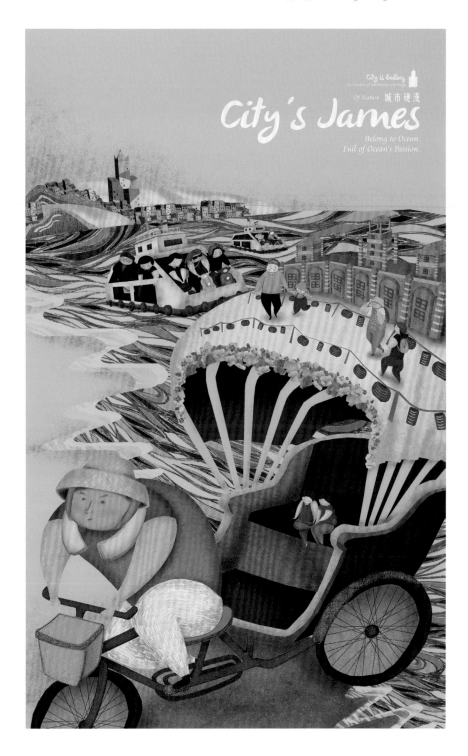

1. 《City's Muse》 The successful big city may have river which is belonging to it, and Love River is the one of Kaohsiung's river. Kaohsiung is changing everywhere throughout from Love River to Kaohsiung harbor. In the transform progress of the city, Love River is changing from the place has no person to the place which poet say "it is just like muse", and the place in people's heart which can take rest in waterside. 2. 《City's James》 Why city can let people miss so much because of the care of people and things or the "flavor" of the life. Besides the hot sun, Kaohsiung also gives people taste of sea. Kaohsiung's sea has strengthen character just like energetic teenage and work hard to ride tricycle for life

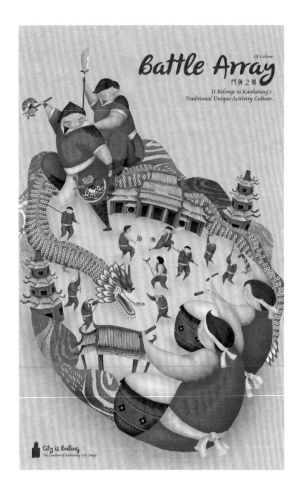

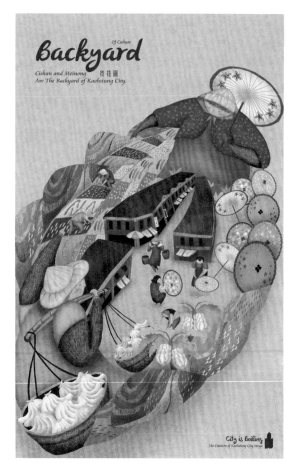

1 | 2 | 3

1.《門陣之鄉》左手拿刀棍，右手拿鍋鏟，是內門民俗與產業的最佳寫照，素有「門陣之鄉」之稱的內門，其中又以「宋江陣」歷史最悠久。動態文化是由民眾力量聚集而成，可以使這個城市廣為人知，內門宋江陣就是高雄最具名之動態文化。 2.《後花園》以兩位農民為主角代表鮮明的旗山香蕉及美濃客家文化，不到半小時車程便可享受田園文化風光，如同是高雄的後花園一般。 3.《文化之潭》 左營蓮池潭西邊亭台樓閣林立，潭畔遍植垂柳隨風搖曳。而每年十月中旬在蓮池潭登場的「萬年季」活動為在地廟宇的宗教慶典活動，周邊的宗教文化加深此潭的文化氣息，造就此地成為著名的文化觀光聖地。

1.《Battle Array》 Using left hands to take sword and stick and using right hands to take pot and shovel are the best portrayal of Neimen folk and industry. Neimen named as "fight village" and "Song-Jiang Array" is the oldest. Dynamic culture is gathered by people's power can let people to know this city and Neimen Song-Jiang Array is the most famous dynamic culture of Kaohsiung. 2.《Backyard》 I make the two farmers as the role of bright Chishan's banana and Meinong's Hakka culture. You only just take drive less than half an hour can enjoy the field scenery and it is like the backyard of Kaohsiung. 3.《Cultural Pond》 The west of Zuoying Lianchitan has a lot of pavilions and lake side is planted swaying willows. The mid-October has the temple's religious ceremony named "Wannian Folklore Festival" in Lianchitan every year, and the religious culture around to enforce Lianchitan's culture richness so that this place becomes the famous culture tourist attraction.

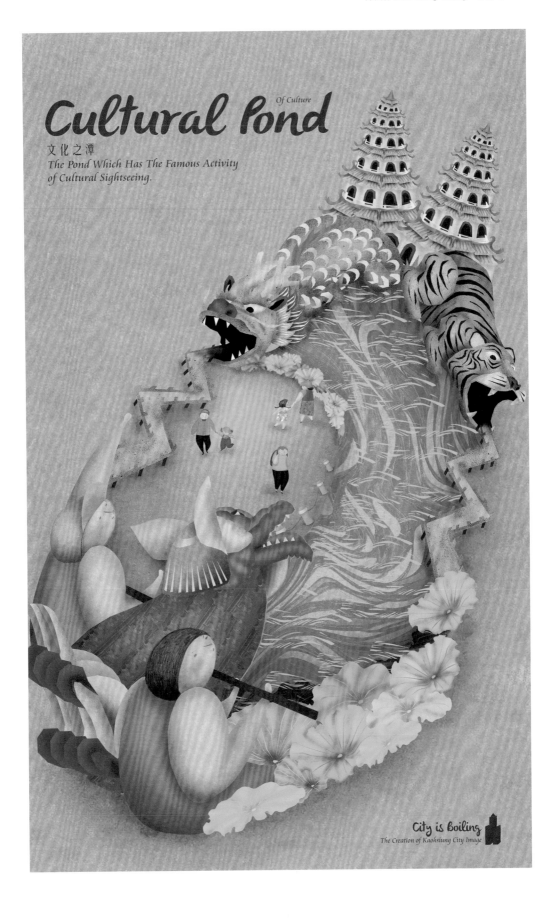

Cultural pond Of Culture

文化之潭
The Pond Which Has The Famous Activity
of Cultural Sightseeing.

City is Boiling
The Creation of Kaohsiung City Image

楊盟玉 Yang Meng Yu

www.flickr.com/photos/56819410@N02/albums

喜歡插畫 電影 怪奇的事物跟獵奇的故事
畢業於高雄師範大學視覺設計系
2013 南海藝廊 - 少女就是愛的訊息聯展
2015 台中一中百年校慶聯展

Fond of illustrations, movies, odd stuff and uncanny
stories. Graduated from Department of Visual Design,
National Kaohsiung Normal University
2013 Nanhai Gallery – Girls are Love's Message
Exhibition
2015 National Taichung First Senior High School –
Alumni Association Gallery Exhibition

⌂ 高雄市大寮區光華路 132 巷 30 號
No.89, Ln. 432, Yongfang Rd., Changhua City, Changhua
County 500, Taiwan (R.O.C.)
✉ abcde90708@yahoo.com.tw

《素食主義者》如果說萬物皆有生命，那吃素就是種看似溫柔的殺生。

《Vegetarian》If every life counts, being vegetarian seems like killing gently.

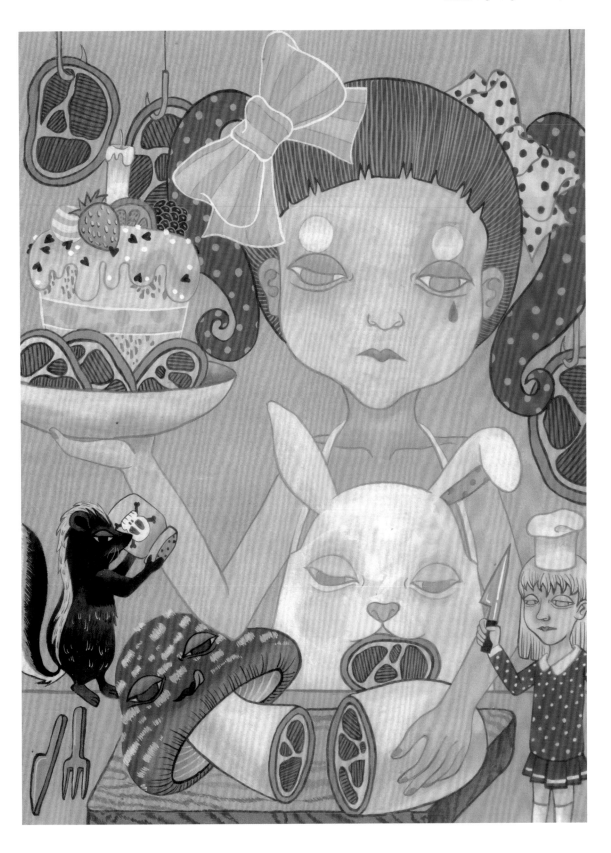

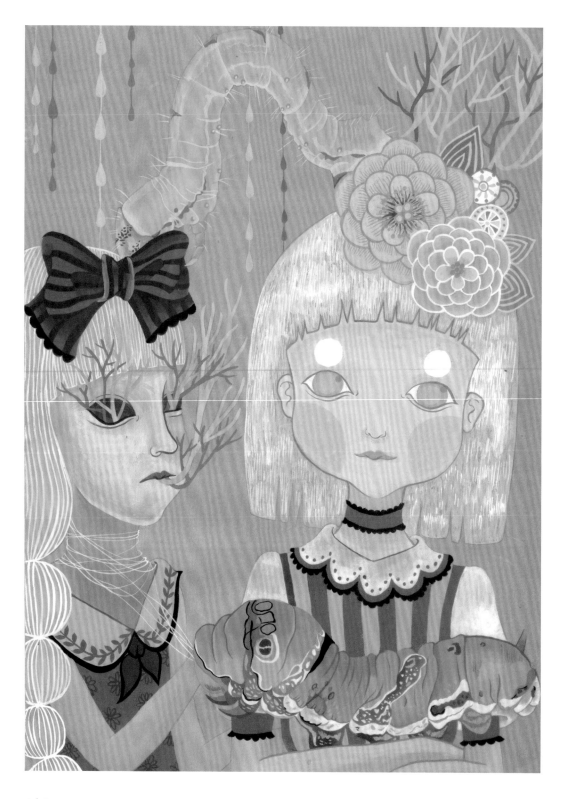

1｜2

1.《某個角落所存在的共生關係》把妳的悲傷 抽離出來／用一種寄生的儀式／轉換成我的悲傷／我們就共同擁有了名為「悲傷」的秘密 2.《獨處時的喧囂》當四周的環境非常安靜時／思緒就顯得吵雜

1.《Mutualism in a corner》Your detached sorrow is parasites, they attach to my sorrow, then we share a secret named "sadness". 2.《Hustle when being alone》Thoughts speak loudly in silence.

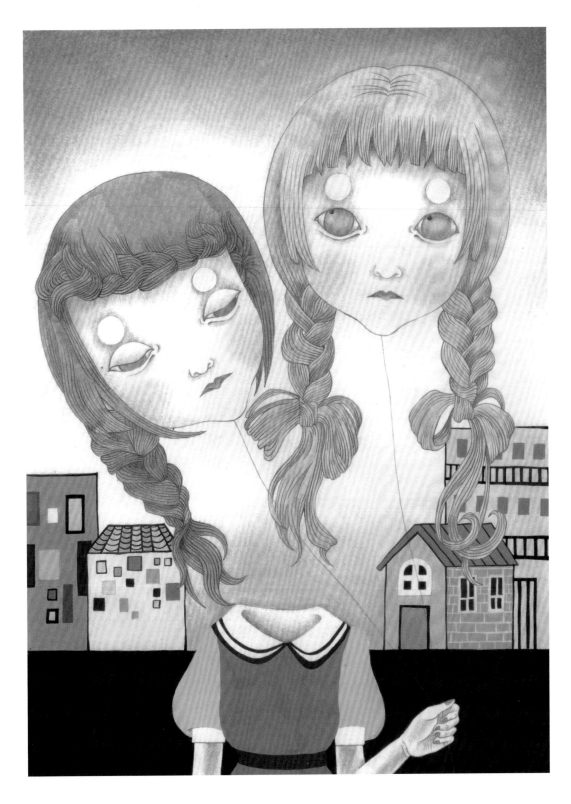

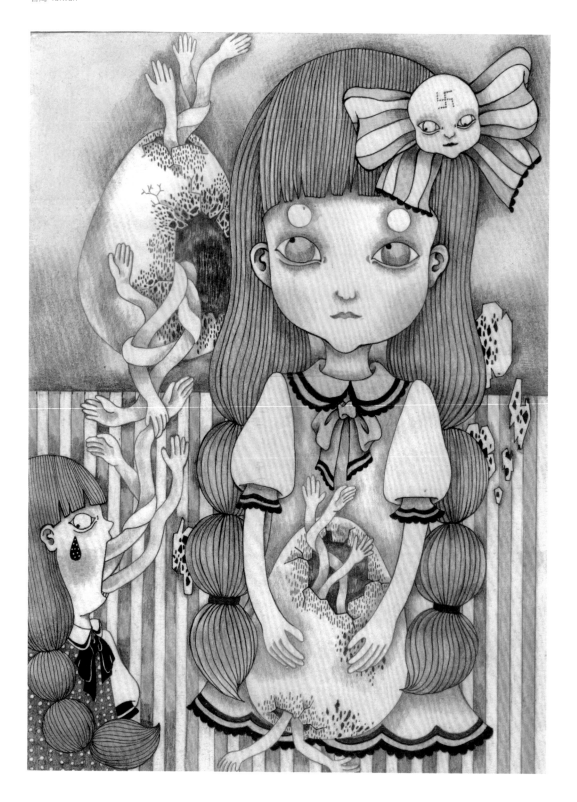

1 | 2

1.《裂縫》裂縫從不只是小小的裂縫／而是有很多無以名狀的念頭流竄其中
2.《她與她們》請不要／用甜美糖衣包裝的執念／入侵她們純淨的愛情聖地

1.《Gap》Gaps are not just cracks, inside flow many undefined thoughts.
2.《She and they》Don't intrude an obsessiveness in dragee into their holy land of love.

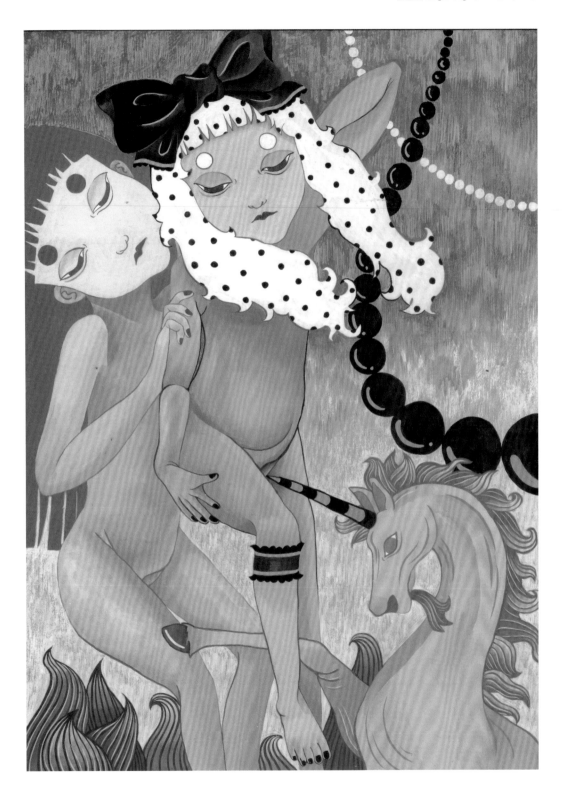

葉懿瑩 I-Ying Yeh

www.iyingyeh.com
www.facebook.com/iyingyeh.illustration

曾於倫敦藝術大學坎伯爾藝術學院Camberwell
College of Art 學習插畫，並取得藝術碩士學位。現
為自由插畫家，作品散見於各報章雜誌書籍等。
2011年系列作品<I feel, therefore I am> 被評選收
入於美國插畫年鑑American Illustration 30 。喜歡
繪畫、設計、花草與飲食生活，認為生活中的人事
物與大自然是創作時最好的靈感來源。著有《季節禮
物：插畫家的台灣旅行記事》圖文作品。

I Ying Yeh is an illustrator from Taiwan. She completed
an MA in visual arts (Illustration) at Camberwell
College of Arts - University of the Arts London. Her
works <I feel, therefore I am> had been selected in
《American Illustration 30》in 2011. She loves design,
drawing, gardening and cooking. Nature and things
from her daily life is her best inspiration.

✉ info@iyingyeh.com

《季節禮物：夏天的杏仁露 》個人創作／墨刻出版
《The Gift of the Season I》 Personal work / MOOK Press, Inc.

1.《季節禮物：屋頂日曬愛玉子》個人創作／墨刻出版 2.《季節禮物：日月紅茶的味道》個人創作／墨刻出版

1.《The Gift of the Season II》Personal work / MOOK Press, Inc. 2.《The Gift of the Season III》Personal work / MOOK Press, Inc.

1.《季節禮物：碧砂漁港逛逛 》個人創作／墨刻出版 2.《季節禮物：春節來這裡找年味》個人創作／墨刻出版

1.《The Gift of the Season IV》Personal work / MOOK Press, Inc. 2.《The Gift of the Season V》Personal work / MOOK Press, Inc.

$\dfrac{1}{2}$ $\Big|$ 3

1.《小說家的休日時光》書封插畫／馬可孛羅出版 2.《機場迷途記》長榮航空機上雜誌專欄插畫 3.《太魯閣燕子口》ELLE Taiwan × LV主題企劃：跟著插畫家去旅行

1.《The leisure time of the novelist》Illustration for book cover / Marco Polo Press, Inc. 2.《Airports for the Navigationally Challenged》 Illustration for magazine / EVA Air: en Voyage 3.《Swallow Grotto（Yanzikou）》Illustration for ELLE Taiwan × LV Project: Art Traveling Taiwan

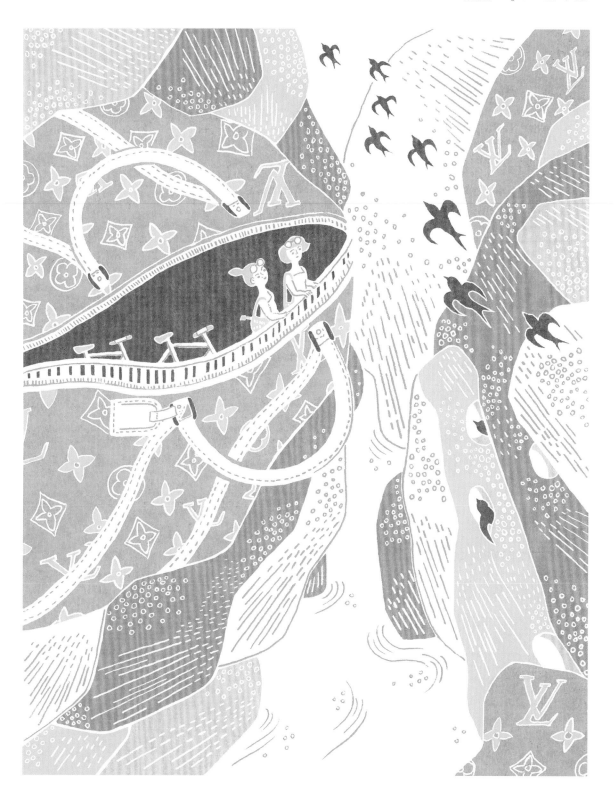

Arrrkal

arrrkalart.tumblr.com

我和許多愛畫畫的人有差不多的起頭，青少年時沉迷日本漫畫而踏入繪畫領域。到大了一點才開始覺得自己並不想光畫些華麗的姿勢和裝飾，因此畫面越來越單純。我臉皮很薄，大部分心情很差時我會試著將情緒具象化，來取代告訴別人這件事。在完成的過程中心裡就越來越平靜，一直以來我以為我畫的東西是很陰鬱的，直到有幾個人告訴我因為看了我的作品而心情好轉，這樣也好。

Like people who like drawing, I was crazy in Japanese manga and step into the painting's field. When I grow older, I find that I don't want to merely draw gorgeous positions and decorations and start to simplify my work. I'm shamefaced. When I feel blue, I try to concreate my emotion and express my true feeling to other with painting. I feel peaceful during the process of painting. I've considered that my works are gloomy until someone told me that he felt better as he saw my work. That's good.

⌂ *12F., No.626, Xinxing Rd., Wuri Dist., Taichung City 414, Taiwan (R.O.C.)*
✉ *sandy2566612@gmail.com*

《Restless》 這是我認為最讓我安心的動作，在逃避時蒙上雙眼，同時又把自己置在一個尷尬的處境，即使逃避了心裡也不會安定。

《Restless》 This is the gesture which makes me feel safe the most. I felt I made myself blind when evading something, and put myself in an embarrassing situation at the same time. Maybe I escaped, but I never felt my mind rest.

《A hint of delight appeared》 流過手臂的涼意和臉上的熱度。

《A hint of delight appeared》 The chill in arms and the heat in the face.

Ching Wei Liu

www.behance.net/robomb-devours

劉經瑋，目前為獨立工作室負責人。專研於插畫設計、包裝視覺、品牌識別等設計文化產業之中。作品常有隱喻暗諷且富含幽默，多收錄於年鑑及設計出版，曾於柏林、東京、台北等地展出，兩度獲得德國紅點獎、日本插畫家協會全場大獎、路易斯威爾國際創意白金獎、倫敦Licc、紐約3×3、紐約AI34、紐約CQ41、香港APPo Vol.5等。未來希望以圖像創造更多美好。

Ching Wei Liu (Devours Bacon) a Taiwanese designer. Studied at the Asia University of visual communication design in Taichung, he simultaneously freelance designs for his independent studio. Devour's Restaurant Studio is a graphic design and art direction studio based in Taiwan. His work has been shortlisted for reddot Design Award, 3×3 New York, Creative Quarterly 41, Golden Pin Concept Award, Platinum Creativity International 45th, GRAND PRIX JIA Illustration, London Licc, FJ art plus, Beijing and CHOSEN WINNER American Illustration, etc. He want more international cooperation in future.

⌂ 台中市南屯區永春南路37號
✉ vogueskyskull@gmail.com

《the little bag》 剛開始「包包」跟著主人生活，一切都很好。直到有一天，因為沒有主人而遭人指點，他開始覺得自己不夠「完整」，這個不完整一路困擾他，他開始在城市遊蕩，找尋自己的定位。
此系列作品在2016年中出版，共有百張插圖。其中獲得日本插畫家協會全場大獎、德國紅點設計獎、紐約3X3等等插畫獎項。

《the little bag》 These illustrations tell the story of a bag's journey. Travelling alone, it feels increasingly incomplete and desper- ate, so it finally teams up with other abandoned bags. The story's aim is to remind the reader that every human being is a separate entity and always "complete". The story is executed with colourful images featuring many details. The bag does not necessarily take centre-stage in the illustrations; it often just blends in unobtrusively with the scenery.

1　3
2

1.《Devours Restaurant》這個作品改編自英國童話，傑克與魔豆，並改編了
場域。主要描繪未來的世界，人們不再需要飼養家畜。肉類是由工廠所做的人
造肉。為了累積財富，巨人餵金母雞吃牛排來獲得金蛋。最後金母雞吃了太多
人造肉而發生突變，因而摧毀了巨人的家。對巨人來說，財富是最重要的事。
人們關注於利益而不是對環境的破壞。至於何者較為重要，唯有災難來臨時人
們才會意識到。 2.《Lard》一服飾品牌T恤的插畫。 3.《Human》台灣意念圖
誌雜誌封面設計。

1.《Devours Restaurant》 This work was adapted from a British fairy tale, Jack and the Beanstalk, and modified because of the space. It mainly depicts that in the future world people no longer need to keep livestock. Meat is made of artificial additives by the factory. For accumulation of wealth, the giant feeds the gold hen steak to get gold eggs. Finally the gold hen eats too much artificial meat then mutates and destroys the giant's home. To the giant, wealth is the most important thing. People are concerned about the benefits but not the damage to the environment. As for which is more important, wait until the terrible end comes then people come to their consciousness. 2.《Lard》 The illustration is clothing brand T shirt. 3.《Human》 The COMPUTER ARTS TAIWAN magazine cover design represent the vitality of the development of all social sectors.

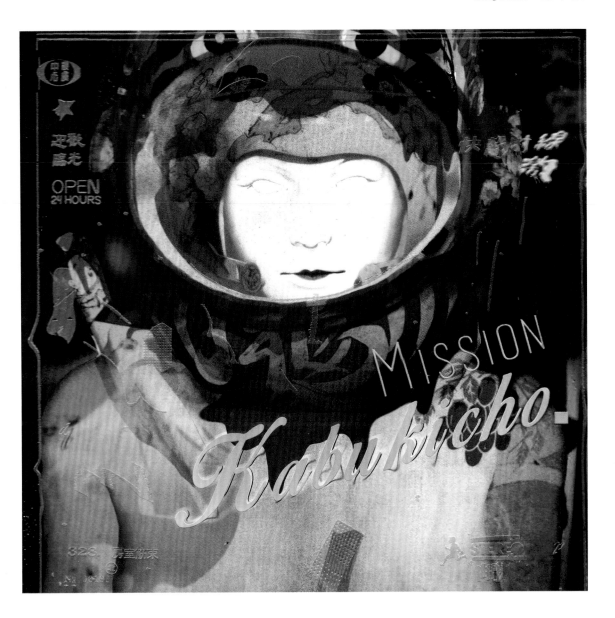

1 | 2　1.《Doom Astronaut》單純為了幽默想法而創作。　2.《Mission Kabukicho》應新宿高島屋百貨邀請的電影原聲黑膠創作。19歲的外星少女因為7000億日圓而陷入新宿黑幫火拚的荒誕故事。

1.《Doom Astronaut》Just for fun.　2.《Mission Kabukicho》Vinyl cover art exhibition / SHINJUKU's movies soundtrack / In 1980s Tokyo, Saka, a 19-year-old alien girl, a professional spy, violence and mayhem ensue after a drug deal gone wrong and more than 700 billion yen in cash near the Kabukicho. A gangs war dragged on in Shinjuku. Gangs of Shinjuku hold a competition of Tattoo, it is a symbol of strength. Winner can earn the 700 billion. Saka want to win the competition and end the gangs war, Saka draw the daruma pupil to wish peace.what she knows about her mission and herself. A comedy and absurd story, as she illustrate the tattooed and learns the spy trade. Movie theme song invited Slow momo, is an indie pop band from Stockholm, influenced by both modern electro pop and 70's organic pop.

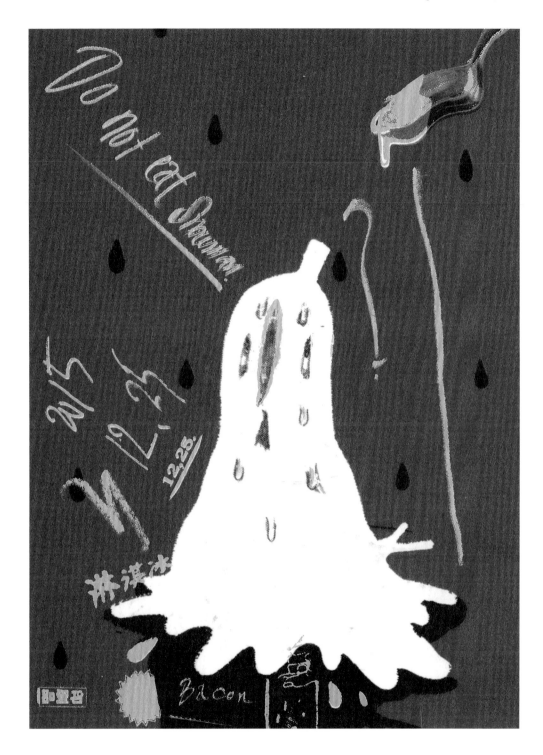

1 | 2

1.《Santa Sundae》勤美綠園道聖誕卡展覽的插圖。 2.《Do not eat snowman》
勤美綠園道聖誕卡展覽的插圖。

1.《Santa Sundae》The illustration of the Park Lane by CMP is a Xmas card
exhibition. 2.《Do not eat snowman》The illustration of the Park Lane by
CMP is a Xmas card exhibition.

Cinyee Chiu
cinyeechiu.com

Cinyee Chiu來自台灣。她大學時主修經濟，在遊戲業工作了幾年後，決定到美國留學插畫。她現在在Maryland Institute College of Art念書，目前是Illustration Practice的碩二生。在求學的這段時間，Cinyee發展了她插畫的風格及對動畫的興趣。她非常享受現在的插畫生活，希望這樣的生活永遠不會結束。

Cinyee Chiu comes from Taiwan. She majored in economics in her undergraduate study, and after few years of working in game industry, she decided to study illustration in United States. Now she is a 2nd year Illustration Practice MFA student in Maryland Institute College of Art (MICA). Cinyee developed her voice in illustration and her interest in animation during the study. She enjoys a lot her illustration life and hopes it never ends.

⌂ *131 W North Ave, Baltimore, MD 21201, USA*
✉ *ccinyee@gmail.com*

《聖誕快樂》聖誕夜，小精靈們因這魔幻的夜晚聚集起來。從左側逆時鐘看下來，他們進行了各種聖誕活動：團聚、做個乖孩子、享用大餐、散播歡樂。究竟畫面中藏了幾隻小精靈呢？

《Merry Christmas》 Christmas eve, little elves gathered for this magical night. From the left side and go counterclockwise, they gathered, had fun, be good and help Santa, feast, and spread joy. How many elves you can find in this picture?

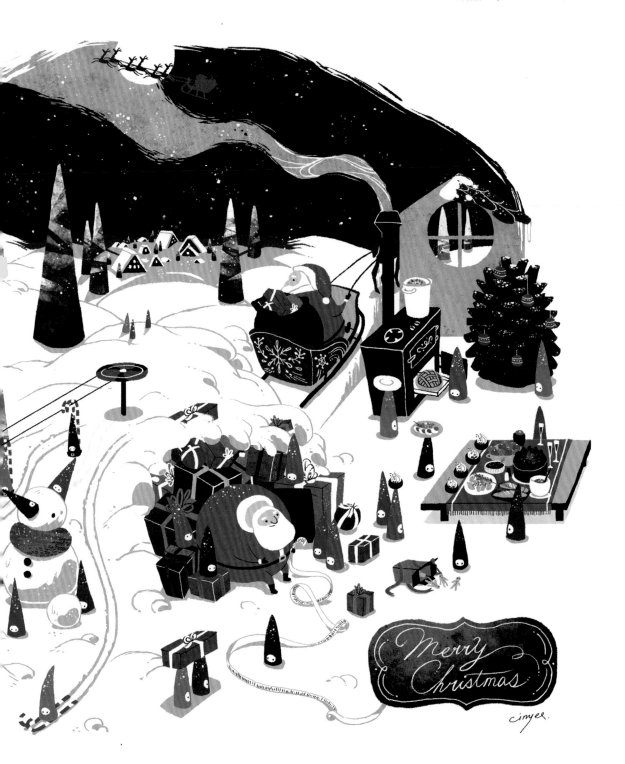

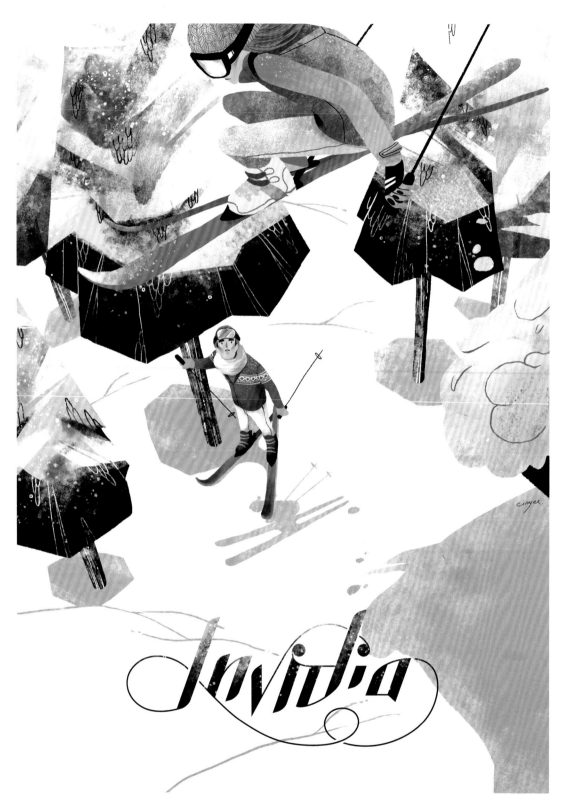

1.《嫉妒》她飛得好高啊。 2.《仁慈》不要緊，這是初學必經的過程。

1.《Envy》She flies so high. 2.《Kindness》It's alright. That's how every beginner starts.

《Terrain》在賣場 Terrain 的購物時刻。

《Terrain》A shopping moment in the store Terrain.

1.《池邊》我們來看看誰會先釣到第一隻魚！ 2.《池內》她們認為我們會上當呢。

1.《Beside the Pond》Let's see who'll get the first fish! 2.《In the Pond》They thought we are going to bite the bait.

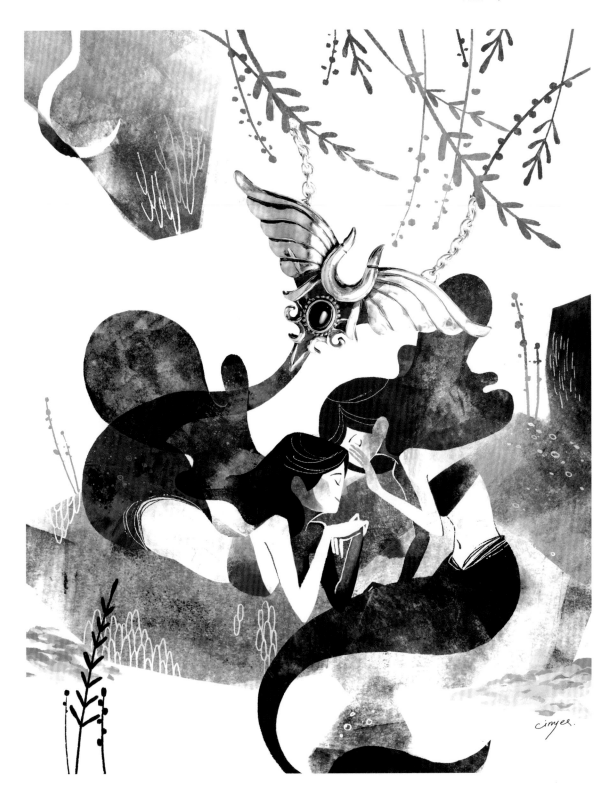

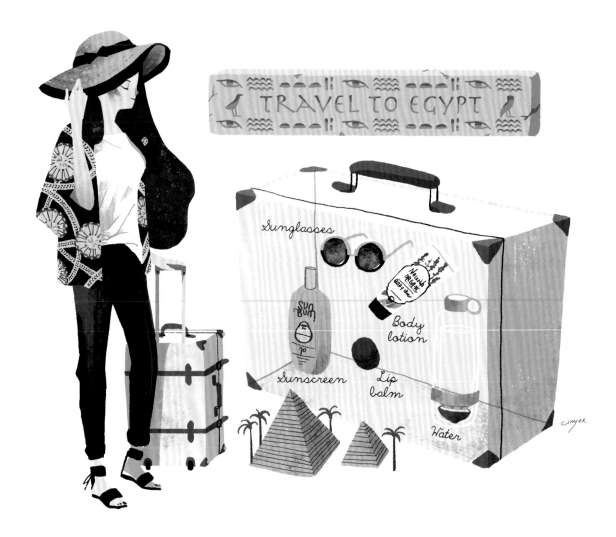

1.《前往埃及的旅行》行李箱內的必備物品一覽。 2.《熊先生的拉麵店》熊開了一間小小的拉麵店。這張圖在畫的時候是以 gif 的角度構思,所以安排了很多可以做不同動態的小細節。

1.《Travel to Egypt》The must have list in a suitcase. 2.《Mr.Bear's Ramen Store》The Bear owns a little ramen store. I was thinking in gif when I arranged the composition, so I put many details that can be animated in this store.

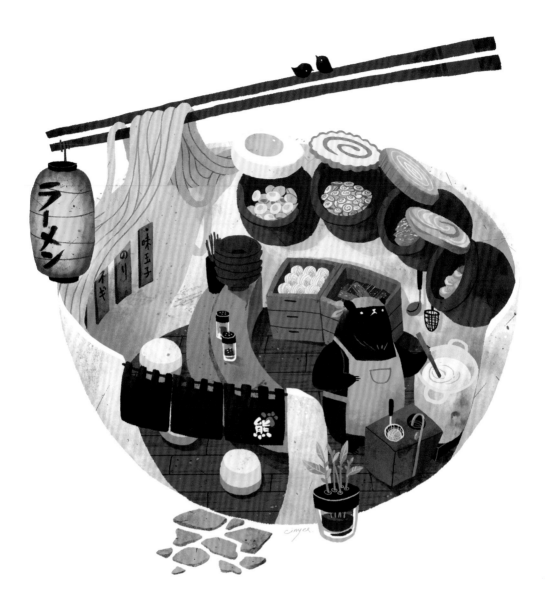

CROTER
www.behance.net/croter

Croter，本名洪添賢，1978年生。設計師與插畫工作者，2004年開始投入獨立創作與設計，擅長使用多種插畫風格與設計結合，並且喜歡使用超現實變異的手法繪製插畫，融合神話故事與諷刺性的幽默，用天真爛漫的語氣緩緩傾訴人生與社會的現實。目前居住在高雄，每天仍持續不斷的在現實量尺與創作理想中持續用畫筆奮鬥著。

Croter, designer and illustrator. In 2004 he started individual creation and design. He is good at combining design with different styles of illustrations. He draws illustrations with the superrealism technique, combining myths and ironic humor, which aims to show the reality of life and society in an innocent tone. He lives in Kaohsiung now, creating his works with reality and ideals.

⌂ *807高雄市三民區明哲路33號5樓之11*
✉ *croter@gmail.com*

《他們都說外面很危險》是兩個互掐脖子的人是城牆，城牆上有建築，有一個出口透著外面的陽光，但是他們說外面很危險。

《Infighting》 Two men who are grabbing each other's neck is the city wall. The building on the wall has an exit with light, but they say outside is dangerous.

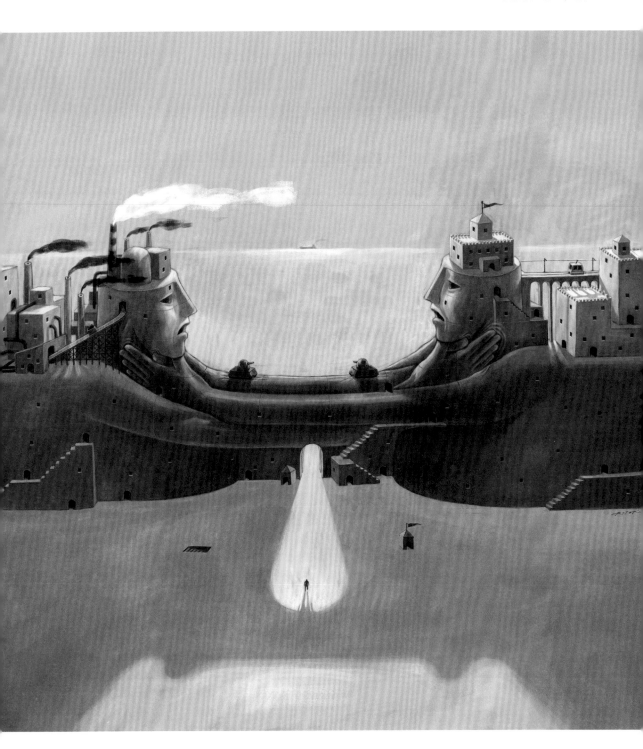

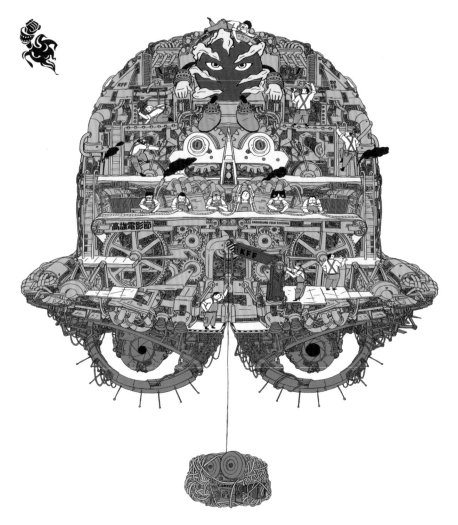

2015 fri sun

10.23 / 11.8

KAOHSIUNG FILM FESTIVAL

高雄電影節

大東文化藝術中心・高雄市立圖書館總館・高雄市電影館

1 | 2

1.《2015高雄電影節主視覺》是以卓別林的帽子與鬍子標記為主輪廓，裡面卻是複雜的機械，也呼應高雄工業都市與『摩登時代』片段。 2.《2015高雄電影節主視覺》這個創作也是為了『2015高雄電影節』主視覺，想要徹底毀壞雄影火球人的酷帥感，作出一種搞笑自嘲的表情，有點許不了哪種的來呼應『愚樂時代』。

1.《2015 Kaohsiung Film Festival》The outline is the hat and mustache of Charlie Chaplin, but the content is complicated machine, which responses the clips of industrial city and "Modern Times". 2.《2015 Kaohsiung Film Festival》he work is also for 2015 Kaohsiung Film Festival, which shows the cool image of Fireball Man with a self-mocking face and responses to the annual theme: Foolish Time.

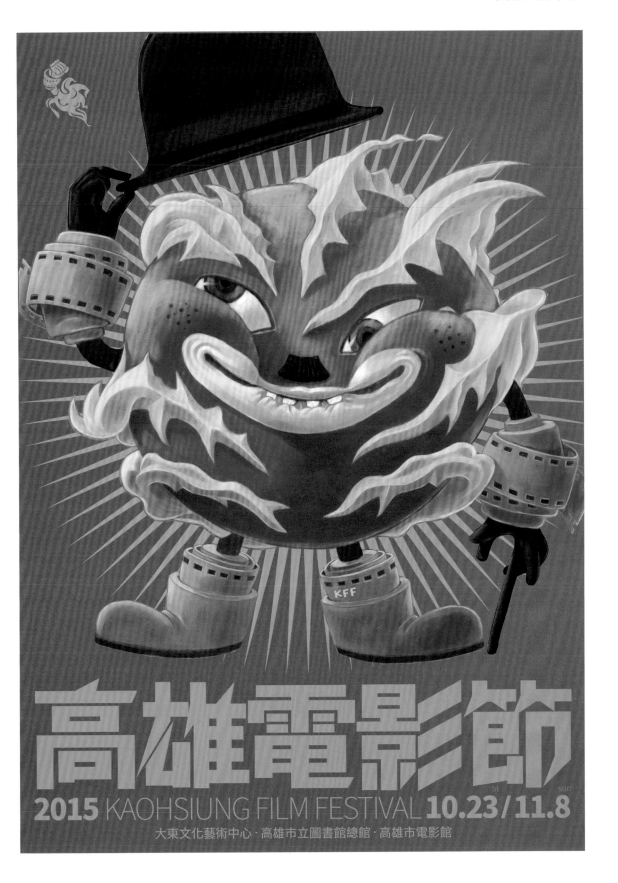

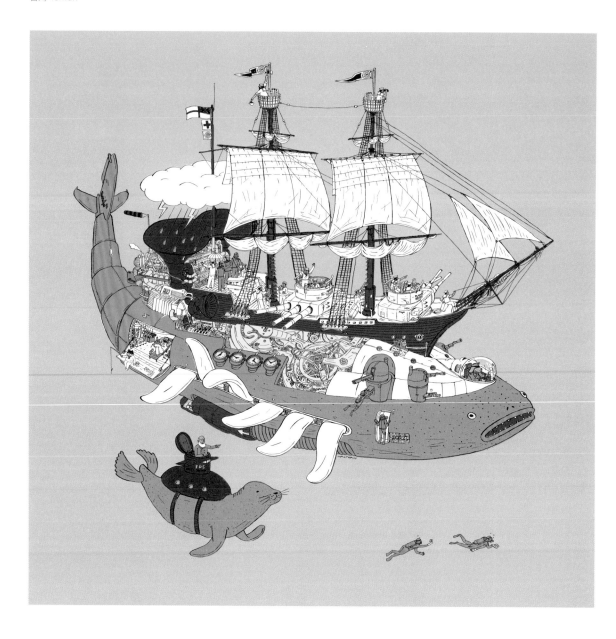

1 | 2

1.《機械化的巨大星鯊附帶小獵犬號的進化探險》生物機械化的小獵犬號除了跟海洋最大的魚類鯨鯊作結合，也融入手錶的陀飛輪與機芯，彷彿整艘船艦的動力是由IWC的機芯驅動，並且在船艦的尾端放置一座水力發電的機器，以呼應IWC在瑞士的製造環境。 2.《機械化的Galapagos象龜附帶海鬣蜥的生態工廠》這個巨大的象龜機器上工作的都是海鬣蜥與鳥類化身的，也暗示這個當初啟發達爾文進化論的特殊群島，其實也正在與時俱進，進化成我們超乎想像的程度了。

1.《HMS Beagle》HMS Beagle combines with Whale shark, the biggest fish in the ocean, and the tourbillon and the caliber of the watch, which seems that the vessel is triggered by IWC's caliber. The end of the vessel installs a hydroelectric power, which suggests that IWC was made in Switzerland. 2.《Galápagos》Galápagos is the incarnation of the marine iguana and the bird, which suggests that the evolution of the island, which inspires Charles Darwin publishing his Evolution Theory, is beyond our imagination.

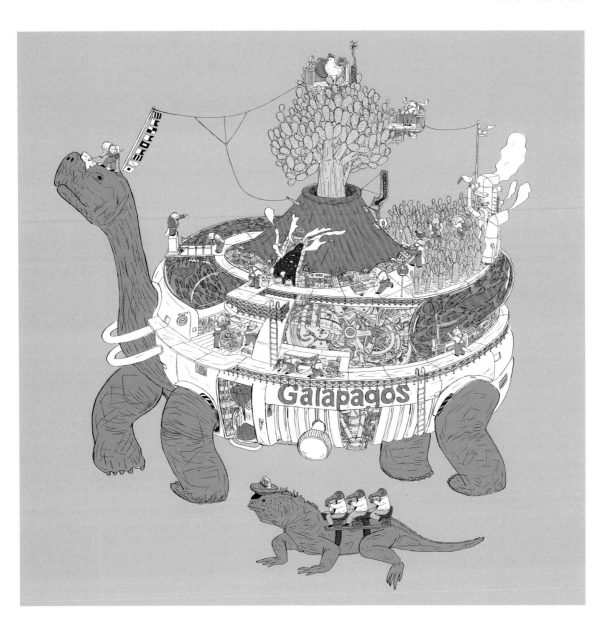

1 | 2

1.《幻城》有時候我們誤解城市的意義，它拆除文化歷史／甚至對於國家位置都模糊了，它成為獨裁附庸／榨乾月光的官員財團都乘著噴射機走了／剩下緩步的大象背負著城市／與被債務燻黑的你我／在黑暗微光中分不出彼此
2.《CATANK》是你的戰友，與你一起撐過那些生活的戰鬥發起前夕，與你一起碾壓那些日常的拒馬鹿砦障礙，或許興奮、喜悅、驚險、憤怒、悲傷，總是在靜靜的陪伴，好像一輛堅固的坦克，引擎聲是令人安心的呼嚕呼嚕。

1.《Unreal City》Sometimes we misunderstand the meaning of a city, which separates culture and history. Sometimes the status of a state is ambiguous, which becomes the appendage of the detector. The official and the megacorporation, which squeeze the moonlight, escape by the jet. The elephants carried the city with slow pace. You and I with debt cannot tell each other in the dark. 2.《CATANK》He is your comrade. Before the day of the war, he was with you. He smashes the obstacles in the daily life with you. As you're exciting, delighted, trilling and desperate, he is with you. Like a strong tank, the sound of engine is relieving.

DUCKCROW
aszi004.wix.com/duckcrow

1994.10.03 生於臺灣臺北 女性 二十歲
目前就讀於國立臺北藝術大學 美術系
創作以諷刺幽默及實驗性質為主
包含繪畫、插畫、漫畫、獨立刊物與動畫製作
近日計畫以版印媒材進行合作性創作計畫
歡迎並期待各種類型態的合作

1994.10.03 born in Taipei. Hi! My name is Duckcrow and I am studied fine arts at Taipei National University of the Arts. I draw inspiration from humor & do it in experimental ways. My current work involves painting, illustration,comic,zine and animation. I am looking forward to collaborating with any kinds of working relationship in this new thriving community.

⌂ *新竹市民族路 177 號*
No.177, Minzu Rd., East Dist., Hsinchu City 30043, Taiwan (R.O.C.)
✉ *aszi_003@yahoo.com.tw*

《日常生活》日常生活中能發現很多個出口，哪裡有光，就往哪裡去。
《Daily life》There are many exits in daily life . Choose the way you like .

ANGERY

1 | 2

1.《神聖母親》每個人都有一位母親、或兩位、或三位。 2.《感覺良好》電視上
會發生什麼事情？今晚打開電視頻道看看吧！

1.《Holy Mother》Everyone has a Mother , or twice , or thrice. 2.《Kimochiii》
What will show on TV ? Les us watch TV tonight !

1 | 2 | 3

1.《櫻桃女孩》櫻桃女孩從不畏懼。 2.《幸運標誌物》你的幸運標誌物是什麼？ 我的是雙頭飛鴿。 3.《現代武器》沒有什麼更甚知覺有力。

1.《Cherry girl》 Cherry girl never fear. 2.《Lucky symbols》What is your own lucky symbol? For me, it is a double-head dove. 3.《Morden Weapon》Nothing is more powerful than feelings.

1.《小甜心》好吃 好吃 好吃 好吃！大家都愛小甜心。 2.《辣妹子群像》墨西哥鬼椒，辣妹子戰士

1.《Sweety》C'est bon, c'est bon . Everyone likes sweety. 2.《Hot ladies》Ghost chili , hot-lady warriors

ANGERY

Eakkarlak
www.facebook.com/eakkarlaks

我叫做Eakkarlak Sangtongchai，可以稱我Tom。
我畢業於易三倉大學（Assumption University）視覺
傳達藝術系。我過去和泰國有名的時尚品牌和英國品
牌合作。目前在泰國曼谷從事時尚插畫家。

"My name is Eakkarlak Sangtongchai, you can also
call me Tom. I graduated from Assumption University,
in the faculty of Visual Communication Art. I used
to work with some Thai famous fashion brands, and
British brands also. Currently, I work as a fashion
illustrator based in Bangkok, Thailand."

⌂ *47/23-25, Rajdamri 2, Lumpinee, Pathumwan, Bangkok,*
Thailand, 10330
✉ *eakkarlak@gmail.com*

《Cocoon》 如果有天，我們能知道自己確切的死亡時間，這終將改變我們的人
生。我們將能理解所謂的「日常生活」是那樣彌足珍貴，而不該虛擲光陰，並去
做該做的事，忽略無關要緊的事，更關注於自己的真正所愛。那天來臨時，我
們才能將人生看得更清楚、並更加完整人生。這幅作品傳遞那天來臨之時、我
們以生活的新面貌破繭重生。／技法：手繪，電腦上色。

《Cocoon》 One day, if we could realize our exact time of death, it would
change our life forever. We shall see how precious our 'ordinary' life can
be. We shall realize that we should not waste our remaining time and
we should prioritize things as they should be, such as we could give less
attention to things that don't matter and be more attentive to those we
truly love. On that day, we shall see our life in much clearer way and live
our life to the fullest. This artwork expresses the feeling of that day where
we are "COCOON" that are given "REBIRTH" with a new aspect of life. /
Technique : Hand Drawing and finish in Computer.

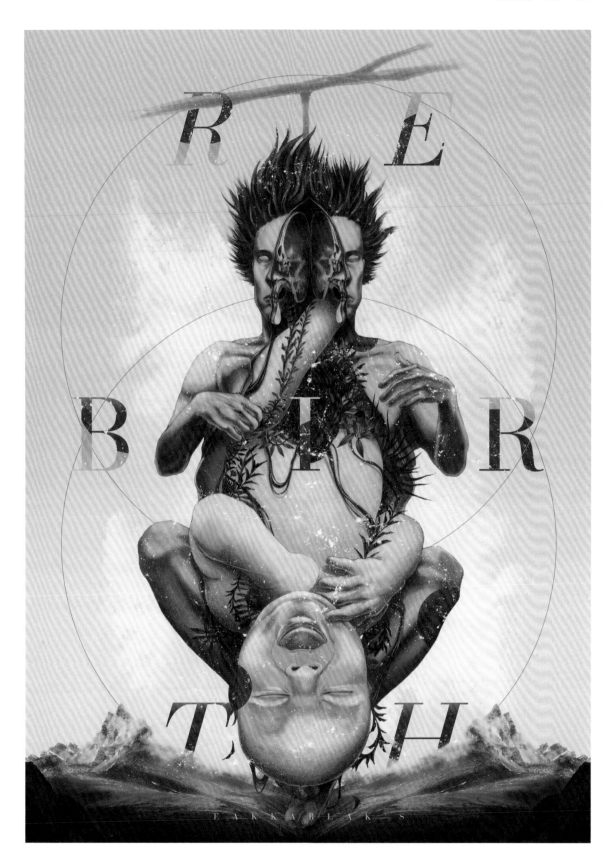

1 | 2

1.《Wild Machine Insects Scarf》昆蟲是和我們生活已久的物種，結合印地安藝術文化的型態、表現形式與概念，表現文明與自然的完美融合。(網站：www.facebook.com/wildmachinestudio) ／技法：手繪，電腦上色。 2.《Wild Machine Begin Scarf》印地安人崇拜自然，並視太陽為父親，大地為母親。並相信萬物，包含人、動物與自然，彼此關係緊密，就像齒輪彼此相依以維持生命。以木頭紋理的感覺、已和形式的花、雨滴、羽毛以其各種野生動物給予我們原始、尊嚴與自然的感覺。／技法：手繪，電腦上色。

1.《Wild Machine Insects Scarf》Drawing of Insects which are the species that live with us for a very long time, combine with the shape, form and ideas of Native American art culture reflect us the perfect compost of civilization and the nature. (www.facebook.com/wildmachinestudio) / Technique : Hand Drawing and finished in Computer. 2.《Wild Machine Begin Scarf》Native American intentionally worship the Nature. They respect the Sun as their father and the Land as their mother. They also believe that everything including Human lives, animals and the nature also has an essential relationship, just like and gear wheels that have to rely on each other to maintain the life machine. The feeling of wood texture drawing, flowers, raindrop, feather and the variety of wild animals contrast with geometric forms give us the feeling of dignity, raw and nature. / Technique : Hand Drawing and finished in Computer.

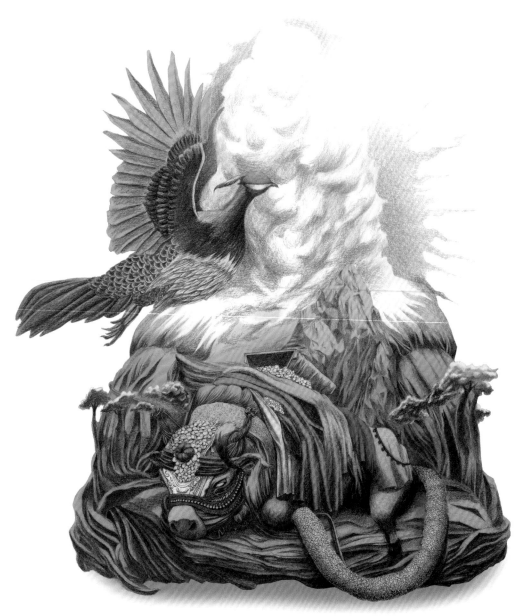

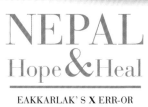

NEPAL
Hope & Heal

EAKKARLAK'S X ERR-OR

1 | 2

1.《Nepal Hope&Heal》這件T恤是為了尼泊爾大地震的公益計畫:「NEPAL:HOPE&HEAL」所設計。尼泊爾主要人口由印度人所組成。因此我決定將濕婆以雲、老樹、黑雉、聖母峰等形象展現,表現其保衛剛經歷災難的尼泊爾傷城。/技法:手繪,電腦上色。2.《Anattata》無魂;無我。作品是為佛教協會計畫。

1.《Nepal Hope&Heal》This T-shirt design artwork was created for Nepal earthquake charity project "NEPAL : HOPE&HEAL". A majority of Nepal Population is Hindu. So I decided to use Shiva god in the form of natural environments like cloud, old tree, Kalij Pheasant bird, Mount Everest as the guardian and Nepalese as a sick cattle who just survived from the big disaster. Technique : Hand Drawing and finish in Computer. / Technique : Hand Drawing and finished in Computer. 2.《Anattata》soullessness; notself This artwork was made for Buddhist associate project. / Technique : Hand Drawing and finished in Computer.

1 | 2

1.《Choulachou London》在 *Choulachou 上的圖案，其顯示了在格林童話中狼的觀點。／技法：手繪，電腦上色。 2.《Senada Flamingo Scarf》為泰國知名品牌 Senada 所設計的圍巾。該作品是在敘說火鳥在黑暗奇幻世界生活的故事。／技法：手繪，電腦上色。

* Choulachou 為英國服飾品牌。

1. 《Choulachou London》 A signature's piece from Choulachou that shows the wolf's persspective in this classic fairy tale of the Brothers Grimm. / Technique : Hand Drawing and finished in Computer. 2. 《Senada Flamingo Scarf》 The scarf design was created for Senada, Thai famous fashion brand. The artwork tells the story of lives of Flamingos in a dark fantasy world. / Technique : Hand Drawing and finished in Computer.

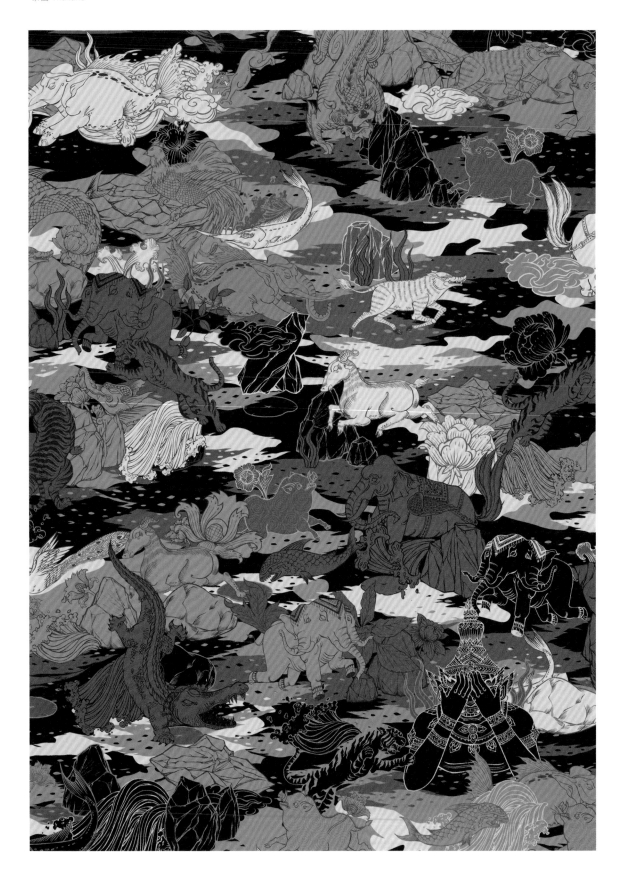

《VANDAVANDA》 我選擇泰國民間習俗中的氂牛與其他神話動物，讓他們在迷彩叢林中玩躲貓貓。並以泰國強烈的形象描繪氂牛與神話動物。迷彩叢林中玩躲貓貓，為設計中次要傳遞的設計意涵；並把大家熟知的躲貓貓帶到作品來。迷彩有時尚的感覺，並帶來整體別緻的平衡。／技法：手繪，電腦上色。

《VANDAVANDA》 I pick Yak and other mythical animals from Thai folklore and makes them play hide and seek in a camouflage jungle. Yak and mythical animals are illustrated with strong accent of Thai identity. Camouflage is a scene for playing hide & seek, a subtle interrelated meaning of the design; also bringing internationality to the collection as hide&seek is a well-recognised play across culture. Camouflage pattern gives a fashion touch, while bringing the overall mood to a delicate balance. / Technique : Hand Drawing and finished in Computer.

Weewill
www.behance.net/weewill

Weewill 是一位住在越南河內的24歲插畫家。她的作品涵蓋她愛的所有事物，包括咖啡、音樂和旅行，帶給觀看者寧靜和鄉愁。

Weewill is a 24-year-old illustrator living and working in Hanoi, Vietnam. Her works contains all the things she loves, including coffee, music and travelling, which bring a sense of calmness and nostalgia for the audience.

⌂ *No.13B- A15- Bac Nghia Tan- Cau Giay district- Hanoi-Vietnam*
✉ *fb.com/weewillweewill*

《no.51》空間（Spaces）系列
《no.51》Form the 'Spaces' series.

1.《Hoi An》2.《Hoi An 2》悲傷卻難忘的會安市之旅，位在越南中南海岸。

1.《Hoi An》2.《Hoi An 2》A sad but memorable trip to Hoi An, an old town in the South Crntral Coast of Vietnam.

1.《hill》雨天，在越南砂壩鎮最棒的咖啡店。 2.《childhood》童年回憶：和爺爺在河內市老區漫步一整天。

《hill》A rainy day at the best coffee shop in Sapa, Vietnam. 2.《childhood》A memory from my childhood: spending a day walking around Hanoi old quarter with my grandfather.

《patterns》 2 《the sofa》樣式（Patterns）系列

《patterns》 2 《the sofa》Form the 'Patterns' series.

DON

國家圖書館出版品預行編目（CIP）資料

AAD 亞洲傑出插畫創作精選 / 陳育民
總編輯. -- 高雄市：陳育民, 2016.04
　　面；　公分
ISBN 978-957-43-3472-8(平裝)
1.插畫 2.畫冊 3.亞洲

947.45　　　　　　　　105006281

總編輯　Chief Editor
陳育民　Chen Yu Ming

編輯團隊　Editing Team
黃郁萱　HUANG, YU-XUAN
蔡欣芸　TSAI, HSIN-YUN
曾懷寬　ZENG, HUAI-KUAN

封面與內頁設計　Graphic design
IF OFFICE

出版者　Publish
陳育民　Chen Yu Ming

出版時間　Publishing Time
2016年4月　Apr. 2016

ISBN　978-957-43-3472-8

地址　ADD
807-72 高雄市三民區汾陽路20號一樓
1F.,No.20, fenyang Rd., Sanmin Dist., Kaohsiung City
807, Taiwan (R.O.C.)

電話　TEL
+886 926 600 147

封面作品由 Evan Raditya Pratomo、Eakkarlak 授權提供
Cover work: Authorized by Evan Raditya Pratomo,
Eakkarlak